FRENCH PORCELAIN OF THE
18th CENTURY

The Faber Monographs on Pottery and Porcelain

Former Editors: W. B. HONEY and ARTHUR LANE
Present Editors: SIR HARRY GARNER and R. J. CHARLESTON

★

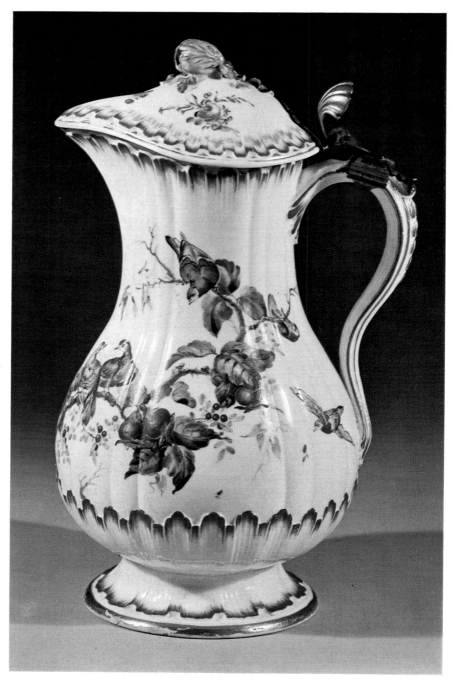

E. MENNECY. ABOUT 1755–60. MARK, 'D V' INCISED
HEIGHT, $9\frac{5}{8}$ IN.

Victoria and Albert Museum
See page 21

FRENCH PORCELAIN OF THE 18th CENTURY

by

W. B. HONEY

FABER AND FABER
3 Queen Square
London

First published in 1950
by Faber and Faber Limited
Second edition 1972
Printed in Great Britain by
John Dickens & Co Ltd Northampton
All rights reserved

ISBN 0 571 04741 6

Second edition © Faber and Faber Ltd 1972

To
WILLIAM KING

FOREWORD

French porcelain has been but little studied in this country. I can recall only one important monograph on the subject in English, published many years ago, while even in France the principal source of information is a book published in 1906, containing nearly a thousand pages without a single illustration of a piece of actual porcelain. Yet the evidence of the market shows the porcelain to be among the most greatly sought-after of all ceramic wares, and this is especially true of the incomparable earlier French soft-pastes of Saint-Cloud, Chantilly, Mennecy and Vincennes.

The vogue of porcelain in France in the seventeenth and eighteenth centuries shared an impulse common to the whole of Europe, consequent upon the vast importations from China. The success of Meissen was also a factor, following up the Chinese influence. But in France the influence of Meissen brought imitation less than emulation. France and Germany were rivals. A crucial stage was reached about 1748–50, when Augustus III of Saxony and Poland and Louis XV of France exchanged presents of Meissen and Vincennes porcelain on the occasion of the marriage of the former's daughter Maria Josepha to the King's son, the Dauphin. This brought the adoption of French Rococo at Meissen and also marked the beginning of the rise of the French royal factory to a fashion-leading pre-eminence in European porcelain. The change of leadership definitely took place in 1756 on the outbreak of the Seven Years' War, when Meissen was occupied by the Prussians. In the same year the Vincennes factory was moved to Sèvres, and for twenty years or more maintained the reputation which its exquisite white porcelain material had earned it. But porcelain was soon to cease to be important as an art patronised by princes; it was in decline, and we may notice an increasing loss of 'porcelain sense' leading to over-elaborate decoration, while the widespread knowledge of the secret and materials of hard-paste, eventually re-discovered by Sèvres in 1768, brought their employment at a dozen more or less commercial factories in Paris, at Limoges and elsewhere.

It is thus on the earlier soft-pastes that the fame of French porcelain rests; and to these most of my book is devoted. Their material has a greater intrinsic beauty and their shapes and decoration reveal a finer taste than any other European porcelain. It will be noticed, however, that the productions of the French Royal Manufacture have been described and illustrated here less fully than their number and import-

ance would seem to require. It should be explained that it is intended to include in this series later on a monograph on Vincennes and Sèvres alone; and in this way, by reserving fuller treatment, it has been possible to avoid a want of proportion in the present volume.

W. B. H.

FOREWORD TO SECOND EDITION (1972)

It has seemed unnecessary to make more than a few minimal changes to the second edition of this book. Four new colour plates have been added, and the bibliography has been brought up to date.

R. J. C.

CONTENTS

ILLUSTRATIONS
COLOUR PLATES

MONOCHROME PLATES

after page 72

PLATES

PLATES

ACKNOWLEDGEMENTS

The grateful thanks of the author are due to the museums and collectors named on the plates for permission to reproduce specimens in their possession. He is particularly indebted to the Victoria and Albert Museum for facilities granted for photography and for the use of official photographs of objects, many of them depicting specimens in the generous gifts of French porcelain made to the Museum by J. H. Fitzhenry in 1901 and 1909. Special thanks are due to the Bedford Corporation and the Trustees of the Cecil Higgins Museum, Bedford, for permission to include some unpublished specimens. The author also wishes to make especial acknowledgement of the permission granted him to include illustrations of pieces in the great exhibition of French porcelain held in the Pavillon de Marsan in Paris in 1929, which was fittingly commemorated two years later in the magnificent plates of *Porcelaine française* by MM. Paul Alfassa and Jacques Guérin. Finally, thanks are due to *The Connoisseur* for permission to reproduce their photograph of Lord Spencer's piece in Plate 36 and to the National Trust for use of the transparency from which Plate G has been made.

1

INTRODUCTION

French porcelain owes its existence as an art to the same causes as produced that of Meissen and the factories of Germany. The importation of porcelain from China reached its height in the latter part of the seventeenth century, and gave rise in France to the same unbounded enthusiasm as in other countries of Europe. Collecting it became the rage, and every prince and nobleman sought to follow the example of Augustus the Strong and the other Electors and Princes of Germany in setting up a porcelain-factory which should bring profit to its owner, as well as fame and a sense of proud achievement. But the method of making porcelain remained an exciting secret. Sold by jewellers and silversmiths, it was hardly thought of as pottery at all. It was luxury ware and remained the medium of a creative art hardly longer than the period of its vogue among the rich. Once the secret was discovered and porcelain became familiar it ceased to attract, and attention passed to other ceramic media, following the Neo-Classical fashions led by Josiah Wedgwood. Such porcelain as was then made had plainly lost all 'sense of the material' and with its all-over painting and great areas of gilding simulating the actual metal, it was by the time of Napoleon Bonaparte in full decline.

<p style="text-align:center">★ ★ ★</p>

But porcelain of a kind was made in France as early as the end of the seventeenth century, at least a decade before the foundation of the first German factory. French porcelain stands apart for this and several other reasons. In the first place French taste was governed by a stronger tradition than the German, and the extravagance of much German porcelain was avoided in France. Though Far Eastern and Meissen models were to a large extent at first the inspiration, there was on the whole much less actual copying than might have been expected. The French preference for measure and restraint gave the porcelain its characteristic grace. It was above all civilised.

Most important, too, was the fact that French porcelain for nearly a century was a soft paste, not a true porcelain or hard paste of Chinese type like the Meissen. This was considered a shortcoming at the time; soft paste was more difficult and costly to make, kiln losses were heavy

and the resulting *pâte tendre* was fragile and liable to crack at the touch of hot water. But its sensuous charm, quite apart from its admirable design, is such that to-day it is valued more highly than the true porcelain. Its soft, easily fusible, oil-like or waxen glaze, allowed enamels to be fused deeply into it, while its low firing-temperature made available a wider range of rich colours. These technical advantages, with the characteristic French taste for measure and supple, graceful rhythms, combined to make it at its best the most charming of all the European porcelains.

<p style="text-align:center">★ ★ ★</p>

The technique of soft-paste or artificial porcelain differs essentially from that of true porcelain. The latter requires the firing together of a mixture of the infusible china-clay (*kaolin*) with the fusible feldspathic china-stone (*petuntse*), two related natural substances. But since the Chinese porcelain appeared to be a sort of glass, it was natural that the first attempts to imitate it should have made use of actual common glass. The known ingredients of this were melted together to form a 'frit' which was ground up and mixed with a white-burning clay and other ingredients including, in the French soft-paste, lime. The resulting mixture was often so little plastic, from the absence of a suitable clay, that it was sometimes necessary (as at Sèvres) to add soap to enable it to be shaped by the potter. In the kiln it was especially liable to collapse, and it is for this reason rare to find plates or dishes of (for example) Saint-Cloud porcelain. Great numbers of Sèvres pieces were rejected as 'seconds', and these slightly defective wares were stored away to be sold eventually, undecorated, in time of stress about 1793 and again about 1800 and later when Alexandre Brongniart as Director decided to give up the expensive manufacture of soft paste. These wares, passing into the hands of the dealers of London and Paris, were decorated in the costliest eighteenth-century styles and sold as genuine old Sèvres. Such half-forgeries abound and in English private collections probably out-number the genuine specimens.

Hard paste, however, was greatly desired, but apart from the eastern French factories, which relied upon Germany, and the experiments of Brancas-Lauraguais, the Duke of Orleans, and possibly others, true porcelain was not made in France until 1769, when the Sèvres chemists had discovered the *kaolin* of Saint-Yrieix, near Limoges. It was not sold in any quantity until 1772, more than sixty years after Böttger's historic discovery of the secret in Germany. This long-delayed French achievement was a hollow triumph. The immediate consequence of the discovery of the *kaolin* was the setting-up of a number of other factories making hard paste of uniform (even mono-

tonous) technical excellence, in nominal infringement of the monopoly held by the Royal Manufacture. By this time, however, much of the earlier enthusiasm for porcelain had died down, and it was soon to lose its fashionable appeal.

<p style="text-align:center">★ ★ ★</p>

French porcelain may be divided into three groups or periods. The first group comprises the incomparable early soft pastes. It dates from the first making of porcelain at Rouen in 1673(?) and the rise of the Saint-Cloud factory towards the end of the seventeenth century; it includes the best work also of Chantilly (1725 onwards) and Mennecy (from about 1735) and the earliest Vincennes, and ends with the establishment of a rigorously enforced Royal monopoly in the interests of Vincennes about the middle of the eighteenth century; orders prohibiting rival establishments were in fact issued in 1745, 1747, 1752, 1753, 1759–60 and in 1766, when the French potters were again allowed within certain limits to make porcelain. This order was evidently issued with a two-fold purpose—not only, like its predecessors, to protect from competition the Royal Manufacture, which it was hoped would prove as profitable as Meissen, but to ensure that the secret of hard paste when discovered should benefit the Royal Manufacture alone.

Though rival porcelain-making by no means ceased altogether, the monopoly orders were to some extent effective over the whole of the second period—roughly the twenty years from about 1750, which was precisely that when the best work of the Royal Manufacture was being done.

The third period dates from the breakdown of the monopoly about 1770, when other factories began to make hard paste with newly discovered *kaolin* of Saint-Yrieix. Many of these were in Paris, in several instances under the protection of members of the Royal family. Strasburg, Niderviller and Lunéville, in the east of France, were also important, but were technically of German derivation, and Marseilles in the south should also be named as standing somewhat apart. All these hard-paste manufactures multiplied and are merged as a body in the industrial developments of the nineteenth century; these were latterly concentrated in the *kaolin* district of Limoges, where the quarry-owning families and multiple proprietors Alluaud, Pouyat and Baignol continued active and powerful, especially the first-named. It should be added that the numerous hard pastes of the latter part of the eighteenth century are in general without much individual character, either in their hard-glass-like cold-white porcelain material or in their usual decoration of sprigs and festoons and 'Pompeian scrolls'.

<p style="text-align:center">3</p>

FRENCH PORCELAIN

The styles embodied in this French porcelain naturally reflect those prevailing in the decorative arts of the time. Thus the earliest decoration of all—the blue lacework borders of Rouen and Saint-Cloud—belongs to the style invented by the elder Bérain and the designers of the *Louis Quatorze*. The blue monochrome alone speaks of the fashion for blue-and-white inspired by the imported Oriental porcelain. In the second quarter of the eighteenth century, as at Meissen, Chinese and Japanese models were much copied, especially the slight Japanese designs named after the potter Kakiemon; they were apparently sometimes copied from the Meissen versions, and not directly from the Japanese. But even these were wrought into simple and rhythmical forms characteristically French. The middle of the century saw the imitation and transformation at Vincennes of the Meissen flower-painting and 'harbour scenes', and the emergence of the half-Classical-mythological and wholly voluptuous *pastorale*, particularly associated with later French porcelain and the Sèvres factory. The Rococo or *Louis Quinze* style, so extravagantly adopted in German porcelain, was measured and restrained in a graceful fancifulness merging imperceptibly into the early French Neo-Classical known as the *Louis Seize*. It should be remembered that the style so named made its appearance some time before the accession of that monarch in 1774. Over all the best work in the best period of Sèvres porcelain was the influence of that prolific genius François Boucher, exerted through the innumerable engravings made after his designs.

As already mentioned the porcelain was chiefly luxury ware. Table-decoration of the German kind had by 1755 gone out of fashion. Porcelain figures had retreated to the mantelpiece and side-table, no longer to be seen from every side. When made for use and not for the cabinet, French porcelain found its typical occasion in the so-called *cabaret* set, a luxurious service for one, with porcelain tray to match.

* * *

The chief factories have already been named. Their history and patronage and their characteristic productions will now be briefly passed in review, in approximately chronological order. The four principal establishments—Saint-Cloud, Chantilly, Mennecy and Vincennes-Sèvres—are by a great deal more important than their nearest rivals, and a frequent use of factory-marks makes the identification of the wares a fairly simple matter. But unmarked pieces are sometimes disputed (the snuff-boxes and other 'toys', for example, are seldom marked), and a note on the differences in paste and glaze is needed at this point. In general it may be said that Saint-Cloud after its first period (when a cold-white paste was the rule) is more inclined to a

yellowish tone than any of the others; it is also commonly more sub-
stantial in build. The earlier Chantilly is singular in having a smooth,
opaque, pure-white tin-glaze like that of faïence; the later lead-glazed
Chantilly is inclined to be yellowish. Mennecy has a brilliant glaze of
a purer milk-white, while Vincennes is whitest of all, though never
cold in tone. Tournay and its satellites Arras and Saint-Amand, which
were technically derived from the later Chantilly, all show a faintly
yellowish tone.

Of these factories Vincennes and Sèvres alone played a European
part. But that was a very important one indeed. The rise of the Royal
Manufacture to a fashion-leading position in Europe was already fore-
shadowed when the interest of Louis XV was aroused through Madame
de Pompadour. An early landmark here was the gift of Vincennes
porcelain by the Dauphine Marie-Josèphe in 1748–49 to her father
Augustus III, Elector of Saxony and King of Poland. This was evidently
sent out of pride in the new French ware, for comparison with the
hard paste of the still-leading Saxon factory at Meissen. With its two
white-glazed groups and white-glazed vase filled with porcelain flowers
it remained at Dresden until the taking of the city by the Russians.

Another stage in the breakaway from Meissen was reached when
Bachelier introduced, in 1751 according to his own account and cer-
tainly by 1753, the unglazed 'biscuit' porcelain as a medium for figure-
modelling. Most of the early figures made at Vincennes were in white-
glazed porcelain, constituting a distinct transitional type, often of great
beauty. The adoption of biscuit meant the renunciation of glaze as
well as of colour in a vain misguided attempt to emulate marble.
The 'goût général', proudly claimed by Bachelier, was a premonition
of the coming Neo-Classical revival, which in its more genial early
form was to dominate the great period of the factory.

The triumph of the French Royal Factory dates from 1756, the
year in which Meissen suffered eclipse at the hands of Frederick the
Great and his Prussians at the outbreak of the Seven Years' War.
This, too, was precisely the year in which the Vincennes factory was
given up for larger premises at Sèvres. Thereafter the Sèvres styles
and innovations were everywhere copied in France, England and the
other countries of Europe, even in Germany at Meissen itself. Biscuit
became more and more the fashion for figures, and pastoral and
domestic scenes replaced the harder, more satirical German subjects
for figure-modelling, while the many coloured grounds introduced by
the French factory, beginning with the *gros bleu*, were everywhere
copied as well as the relatively infusible glaze of hard paste allowed.
The lead so established lasted, in gradual decline, until the Revolu-
tion, when the luxury art of porcelain virtually ceased to exist.

2

ROUEN

The patent granted in 1673 to Louis, son of the Rouen *faïencier* Edme Poterat, included the manufacture of porcelain, and the date is of historic importance, though little seems to have been actually made. In a report of 1694 on the Poterats' application for a renewed faïence-patent it was stated that 'the secret [of porcelain manufacture] was very little used, the petitioners devoting themselves rather to faïence-making'. Louis Poterat claimed exclusive personal knowledge of the processes and alleged that the small quantity of porcelain produced was made by himself alone, without the assistance of workmen who might have divulged the secret. He died in 1696, 'crippled in his limbs by the ingredients used in his porcelain,' and the secret seems to have died with him, at least as far as Rouen was concerned.

The identification of Poterat's porcelain has depended largely upon local opinion, by which a class marked with the letters 'A.P.' (1), sometimes with a star, and more probably of Saint-Cloud manufacture, has been doubtfully claimed as Rouen. Even if the 'P' stood for Poterat and if the star was taken from the arms of his family as *Sieurs de Saint-Etienne* (as is claimed), the 'A' is not accounted for. The mark is also very similar to some appearing on admitted Saint-Cloud. Moreover, the form of a three-lobed spice-box with this mark (compare *Plate* 5B) almost exactly corresponds with some specimens in Bottger's stoneware and in Meissen and Vienna porcelain. all of eighteenth-century date and unlikely to have been imitated from Rouen examples. The French boxes were probably copied from Meissen at a date long after the Rouen porcelain had ceased to be made.

The authentic Rouen porcelain may perhaps be identified by its resemblance to the Rouen faïence and to a silver-mounted porcelain mustard-pot in the Sèvres Museum with the arms of Asselin de Ville-quier of Rouen. A *sucrier* in the Rouen Museum (2) is apparently part of the same service as the Asselin mustard-pot, with precisely similar decoration but without the arms. A bluish- or greenish-toned and brilliant glaze and a dark inky blue applied in fine hatched lines as in an engraving are characteristic. Among these rare specimens

(1) *Plate* 5A; (2) *Plate* 1A.

may also be mentioned a cup at the Victoria and Albert Museum (Fitzhenry Gift), a globular vase in the Sèvres Museum with gadrooned borders and freely painted arabesques amidst which climbs a grotesque figure, and a similar tea-pot in the Musée des Arts Décoratifs. The close-packed scrolls and white arabesques reserved on a blue ground seen on the Rouen faïence are paralleled on a pair of narrow-necked bottles formerly in the Waddington Collection, and two globular *pot-pourri* vases formerly in the Chavagnac Collection (1), with rosettes and arcaded ribbing in relief and a border of arabesques, formal flowers and dots.

All these are painted in blue only, but local tradition claims a few very rare polychrome pieces as Rouen. Two salt-cellars in the Gouellain Collection in the city museum (figured by Milet), painted in red, green and blue and in red and blue respectively, are examples of these.

It is said that at the end of the eighteenth century, hard-paste porcelain was made at Rouen by Delamettairie and by Sturgeon, but it seems to have been of no artistic importance.

(1) *Plate* 1B.

SAINT-CLOUD

The first productive porcelain factory to be established in France was at Saint-Cloud near Paris. It was claimed by the proprietors that porcelain was made at their factory before 1678, but this is not certain. The close resemblance of the early Saint-Cloud paste to that attributed to Rouen suggests a connection which has never been proved. A painter named Chicaneau, presumed to have been a member of the Saint-Cloud family, is recorded at Rouen, but as late as 1720.

Letters-patent were granted in 1702 to the family of Pierre Chicaneau (d. 1678), who were stated to have improved upon the process discovered by him, and since 1693 to have made porcelain as 'perfect as the Chinese'. Their factory was under the protection of Monsieur, the King's brother. In 1679 Chicaneau's widow, Berthe Coudray, had married Henri-Charles Trou, who secured for the factory the protection of the Duke of Orleans; but the porcelain secret seems to have been the exclusive property of the Chicaneau family until after the death of Berthe Coudray in or about 1722, when a renewed patent mentioned Henri (II) and Gabriel Trou; in 1700 it had been reported that the Duchess of Burgundy was received at the factory by 'MM. Chicaneau'. About 1722 also, Marie Moreau, the widow of Pierre (II) Chicaneau, who had been manager at Saint-Cloud, seceded and with the help of her cousin by marriage, Louis-Dominique-François Chicaneau, made an independent manufacture of what had been the Saint-Cloud branch establishment in Paris, in the rue de la Ville-l'Evêque (Faubourg Saint-Honoré). L.-D.-F. Chicaneau took this factory on lease from Marie Moreau in 1731. In 1737 the Saint-Cloud factory was partly destroyed by fire. In 1742–43, Henri (II) Trou secured the sole proprietorship of both factories, at the same time claiming 'a new secret' of perfecting the china, communicated to him by his patron the Duke of Orleans. Henri (II) Trou died in 1746, leaving both factories to his son Henri-François Trou, who in 1764 took into partnership Edme Choudard des Forges. In 1766 the concern went into liquidation.

It should be noted that the 'Morin' reported by Dr. Martin Lister, in his report of a journey to Paris in 1698, as the proprietor of Saint-Cloud in that year, does not appear in the factory records. He has been identified by Havard (*Céramique Hollandaise*, pp. 235, 236), as

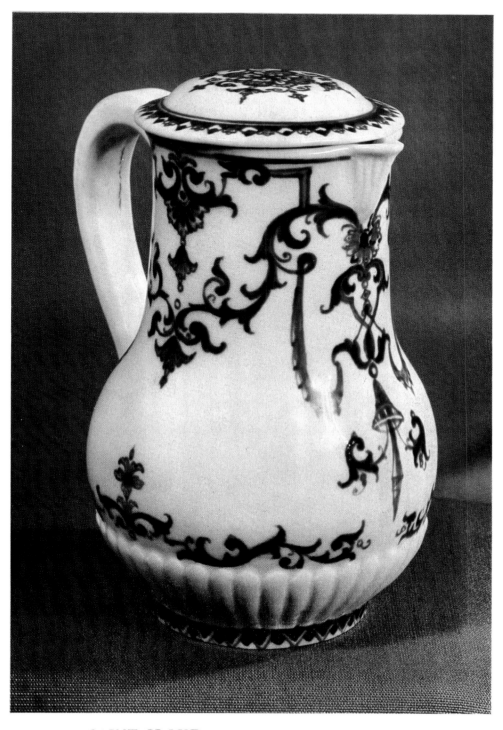

A. SAINT-CLOUD. LATE-SEVENTEENTH OR EARLY-
EIGHTEENTH CENTURY. HEIGHT, $5\frac{1}{2}$ IN.

Victoria and Albert Museum
See pages 10, 11

François de Morin (d. 1707), a chemist who submitted to the Académie des Sciences in 1692 a *Mémoire sur la fabrication de la porcelaine*. It has also been pointed out that faïence was made at Saint-Cloud, at a separate factory, under the direction of one Morin.

There is some uncertainty about the marks used at Saint-Cloud and at the rue de la Ville-l'Evêque, the productions of which are apparently indistinguishable from those of the parent factory. In a petition dated 1696 it was stated that the porcelain would be marked with a *fleur-de-lys* or a sun. The former mark is almost unknown (but there is a specimen with it in the Grollier Collection, attributed to Saint-Cloud); the latter occurs on some pieces (1) of noticeably colder tone than those bearing the well-known mark 'St C' over 'T' (2), which presumably was not used until Trou was admitted to the patent rights and secret in 1722. This mark, which is usually in blue but was occasionally incised or painted in red or other colour, is often accompanied by other letters, crosses, dots, etc. These letters sometimes appear alone on pieces unmistakably of Saint-Cloud paste and glaze, and some of them have been claimed as the marks of other factories, such as Rouen, Lille, Etiolles, etc., but apparently in error.

The typical Saint-Cloud is one of the most distinct and attractive of porcelains, and not the least part of its charm lies in the quality of the material itself. It is rarely of a pure white, but the warm yellowish or ivory tone of the wares of the best period is sympathetic and by no means a shortcoming; and while actually very soft and glassy, it has a firm, smooth texture quite unlike any other. The glaze often shows a fine satin-like pitting of the surface that helps to distinguish it from the brilliant shiny glaze of Mennecy, which is otherwise somewhat similar. The heavy build of the pieces is also characteristic and is saved from clumsiness by a fine sense of mass, revealed in the subtly graduated thickness of walls and a sensitive shaping of edges.

It is not possible to classify the Saint-Cloud porcelain into very distinct periods. The early pieces marked with the sun-face suggest that at first it was of a colder, more bluish-white tone than it assumed later. The influence of Meissen porcelain was obviously strong in the period 1730 to 1750. In the last twenty years difficulties were created by the Vincennes–Sèvres monopoly, and to this last period may be assigned many of the imperfect and rather smoky-toned white figures of *putti* on *pot-pourri* vases, pastille-burners, etc. But dating is often difficult. Pieces mounted in hall-marked silver are useful as giving the latest possible dates, and a list issued by L.-D.-F. Chicaneau in 1731 (pub-

(1) *Plates* 2, 6A; (2) *Plates* 3A, 7B, C

lished by Chavagnac and Grollier), detailing the productions of the Paris branch, is of the utmost value for this purpose.

The forms of the porcelain are of great interest and beauty. The frequent influence of silver is noticeable (as in most contemporary porcelain), and the same shapes are sometimes found in Rouen faïence, but in general they are strikingly original and appropriate, showing a certain austerity characteristic of the time. Bold reeding and gadrooning (1) enhance the qualities of mass already mentioned. The beautiful line of the substantial handles is often emphasised by an effective rectangular section (2). For toilet-pots, butter-dishes and the like, a simple, well-proportioned, cylindrical form with lightly domed cover (3) was especially favoured. Three-lobed spice-boxes (*épiciers*) with strawberry-and-calyx-knobbed lids (4) are apparently peculiar to Saint-Cloud in French porcelain (though claimed also for Rouen). Many beautiful sorts of applied and moulded reliefs included the Chinese plum-blossom (5) copied from the *blanc de Chine* which Saint-Cloud itself so closely resembles, as well as stylised flowering plants (6) adapted from silver. Modelled leaves, flowers and fruits were sometimes freely garlanded about the forms with charming effect: berries pierced like beads seem to have been used first at Saint-Cloud and copied at Mennecy. Imbricated scale- or pine-cone pattern (7) and bold simple grooving were favourite devices; saucers were often of *trembleuse* pattern (8) with a raised ring; plain knobs in the form of an inverted truncated cone (9) are almost peculiar to Saint-Cloud, and foot-rings are frequently very high, leaving a deep hollow under the base. Flat or broad pieces (such as the lids of the big tureens) have often sagged in the firing, and plates, though mentioned in the advertisement of the rue de la Ville-l'Evêque, are extremely rare. A beautiful dish in the Musée des Arts Décoratifs (10) is therefore all the more remarkable. It is noteworthy that plain pieces mounted in milled silver bands are found much more frequently in Saint-Cloud than in any other French porcelain, suggesting an arrangement with the Paris silversmiths.

The snuff-boxes (11), shown by silver mounts to have been made between 1723 and 1750, are sometimes in the form of simply modelled figures of sheep (12) and other animals (13), always suitably rounded and indefinite. A certain boldness of style helps to differentiate them from the similar objects made at Chantilly and Mennecy. A bowl and cover

(1) *Plates* 3A, 6B, etc.; (2) *Plate* 8; (3) *Plates* 2, 3B, etc.; (4) *Plate* 5B; (5) *Plates* 8, 10B; (6) *Plates* 9, 11; (7) *Plate* 10A; (8) *Plates* 7A, C; (9) *Plates* 2, 3B, etc.; (10) *Plate* 4; (11) *Plates* 17, 50A–D; (12) *Plate* 50B; (13) *Plate* 50C.

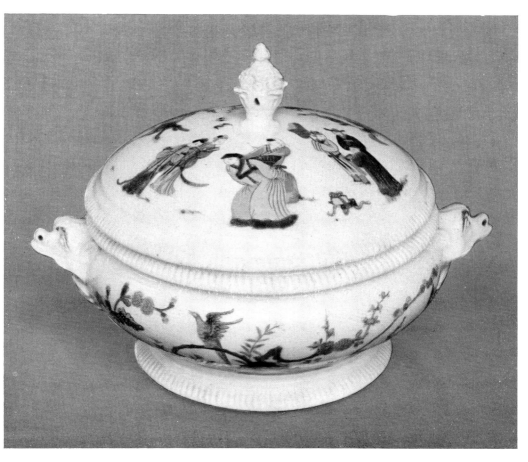

B. SAINT-CLOUD. ABOUT 1735. DIAMETER, 9¾ IN.

Victoria and Albert Museum
See page 12

in the Musée des Arts Décoratifs, Paris, of unquestionable Saint-Cloud porcelain, has a knob in the form of a rabbit and is a document for the Saint-Cloud 'toys'. A true modeller's sense is shown in the *becs de corbin* (1); while jugs and tea-pots in the form of men and birds (Sèvres Museum) and dragon-handles and spouts (2) show the same quality. The larger independent figures are usually of the later period (1730 onwards) and mostly left unpainted; L.-D.-François Chicaneau's advertisement (1731) referred to 'all sorts of grotesque figures and tree trunks'. Two grotesque *Chinamen*, and another seated, at the Victoria and Albert Museum (3) are masterpieces of their kind, admirably modelled. A pastille-burner in the Musée des Arts Décoratifs, Paris, in the form of a man's head, shows the same bold stylising. All seem to be the work of one gifted anonymous modeller. A *Chinaman* and companion (4) in the Musée des Arts Décoratifs, are painted with Japanese sprigs. A rare type is represented by a bust of Watteau on a scrolled pedestal, formerly in the Chavagnac Collection. Some other figures are close copies of Meissen models and apt to be lifeless. To the last period belong certain *pot-pourri* vases or pastille-burners (5), often with figures of naked boys, identified as Saint-Cloud by the form of leaves and rocks. Unfortunately the material was now no longer of uniformly fine quality, a dingy-white glaze often disfiguring it. Saint-Cloud figures are apparently never marked, and are often the subject of dispute.

The characteristic Saint-Cloud painting was in blue in the *Louis Quatorze* style, in a distinct variant of the Rouen faïence-painting. The lacework scrolls and *lambrequins*, which were the chief motives (6), remained in favour for many years (until 1735, if not later) and are never more charming than on Saint-Cloud porcelain. Occasionally the same decoration was rendered in the enamel-colours of Japanese Kakiemon porcelain, as in a two-handled sauceboat at the Musée des Arts Décoratifs; and in the same collection is a rare specimen in which the blue-painting has been washed over with a beautiful translucent green. A typical bottle with this blue-painting, shown at the Paris Exhibition in 1929, is dated 1726.

An interesting small class is decorated with raised gilding, tooled and impressed with stamps, and painted over in translucent colours, resembling some Saxon painting associated with C. C. Hunger of about 1720 to 1725 and similar also to some later work of the Meissen, Dresden and Berlin artist C. F. Herold. Its association with enamel-painting of a usual Saint-Cloud kind seems to show that it is here

(1) *Plates* 17B, D; (2) *Plate* 3A; (3) *Plates* 14, 15A; (4) *Plate* 16; (5) *Plate* 15B; (6) *Plates 2-7 and Colour Plate A.*

11

factory decoration. It is usually seen only on small pieces—cane-handles, snuff-boxes (1), little pots and covers, etc.—often mounted in silver with hall-marks which range in date from 1723 to 1738–39. Specimens are in the Louvre, at the Victoria and Albert and British Museums, at the Musée des Arts Décoratifs, and at Sèvres. At the last-named also is a pot-cover in which the gilding and some underglaze blue-painting have been painted over with a clear pink enamel; translucent green was often used in this way over the gilding, giving a delicate jewelled effect, recalling the much later 'jewelled Sèvres' of about 1780 attributed to Cotteau. Gilding is otherwise rare on Saint-Cloud, in spite of Dr. Lister's statement that he saw fired-on gilt chequer-patterns being applied to the porcelain. It is seen, however, on some knife-handles (2) attributed to the factory on the showing of a peculiar faded-looking red in combination with green and dark underglaze blue, which occur also on a marked pot at the Sèvres Museum.

Painting in colours imitated from the Kakiemon decoration shows in Saint-Cloud a characteristic bold touch, and the same style is recognisable in the rare figure-painting, as on the big tureens (3), on some snuff-boxes (4), and on a pot and cover at South Kensington with nuns and monks (5). A strong brownish black, a rich emerald-green and a warm orange are distinctive colours in this class. A silver-mounted snuff-box with the Kakiemon painting (Victoria and Albert Museum (6)) bears the hallmark for 1738–39 and is therefore a document for dating. An unusual specimen with polychrome painting is a bowl with cover and stand, at the Musée des Arts Décoratifs, painted with Japanese (Imari) chrysanthemums and foliage (7), and some rare copies of the Chinese *famille verte* (8) should also be noted.

(1) *Plate* 17c; (2) *Plate* 51c, E; (3) *Colour-Plate B*; (4) *Plate* 50b; (5) *Plate* 17a; (6) *Plate* 50a; (7) *Plate* 13; (8) *Plate* 12.

4

CHANTILLY

History: This famous porcelain-factory (Dept. of Oise) was founded by Louis-Henri de Bourbon, Prince de Condé, in 1725, but a patent was not granted it until ten years later. It remained from the beginning under the direction of Ciquaire Cirou, until his death in 1751. From this date the management was in turn in the hands of Buquet de Montvallier and de Roussière (1751–54), de Montvallier alone (1754–60), Pierre Peyrard (1760–76), Louis-François Gravant (1776–79), *Dame* Gravant, his wife (1779–81), and Antheaume de Surval (1781–92). In 1792 it passed into the hands of an Englishman, Christopher Potter, who had owned a hard-paste factory in the rue de Crussol, Paris. About 1800 Potter was ruined by his speculations and gave up the works. Soon after this, several other factories were started in the town, making wares of little artistic importance. It is doubtful whether the soft-paste porcelain on which alone the fame of Chantilly depends was made in any quantity after about 1780.

Productions: The porcelain made before this date divides itself into two classes. The earlier and finer, dating from the period of Cirou's management, is distinguished by the use of a glaze made white and opaque with tin-ashes, as in a faïence or delftware glaze. It has been stated, without proof, that Robert Dubois of Chantilly (afterwards of Vincennes) had been at Saint-Cloud, and also that Cirou had been employed at the rue de la Ville-l'Evêque. However this may be (and the actual pastes of the two porcelains are not dissimilar), the tin-glaze of early Chantilly, with its beautiful milky whiteness and smoothness, is absolutely distinct and without parallel in the history of porcelain. It has been asserted that this tin-glaze was given up about 1735, but many pieces assignable to later dates prove its continued use at least until the death of Cirou and on occasion for some time afterwards; important orders (such as the 'Villers Cotterets' services made for the Duke of Orleans about 1770 (1)) seem always to have been made with the tin-glaze. But in the second period, beginning about 1750, a soft porcelain with the normal lead-glaze of slightly yellowish or creamy tone was commonly used; it was still of fine quality.

(1) *Plate* 30c.

Though many pieces were left unmarked, the well-known Chantilly hunting-horn remained in use as a mark throughout the existence of the soft-paste manufacture; but apart from the broad distinction between the red enamel mark of the earlier period and the blue enamel and underglaze blue of the later, it affords no help in dating the wares. Exceptionally, black or gold was used for the early mark, and crimson for the later. The word 'Chantilly' written in full, in blue, appears (but rarely) on late wares painted with sprigs in underglaze blue. About 1750 or a little later, when the Vincennes models began to be copied, a blue enamel mark was not unusual. The red mark was as a rule drawn very carefully, whilst the blue is often almost unrecognisable as a horn. The mark incised occurs on one of two white figures of a boy and girl, and a raised horn is said to appear on the apron of the figure of a woman with a pannier on her back, referred to below (all Chavagnac Collection). Initials, numerals and cryptic signs commonly accompany the mark, but the workmen to whom they presumably refer cannot in most cases now be identified. The incised names of modellers and throwers, such as *'Bonnefoy'* (or *'Bonfoy'*), *'Gabin'* (also *'Gabine'* and *'Cabin'* (1)), *'Duchet'* (or *'Duchene'*) and others, apparently abbreviated or misspelt, also occur, but only on the less interesting later wares. The work of these and of the numerous other painters and modellers whose names are known cannot be distinguished. Among the staff of the factory, however, should be noted the brothers Gilles and Robert Dubois, later employed at Vincennes, and Louis Fournier, presumed to be the Vincennes modeller afterwards making soft paste at the Blaataarn, Copenhagen.

The most characteristic Chantilly is that with forms and decoration inspired by the 'Kakiemon' porcelain (2). The Prince de Condé had a large collection of these Japanese wares, which were believed by Jacquemart to be Corean. (The name *'décor Coréen'* is still current for the Chantilly versions.) It may be conjectured that their vogue lasted during the fifteen years between 1725 and the death of the Prince in 1740. It should be remembered, however, in this connection that Meissen porcelain decorated in the same style was at the time well-known to Cirou and the Prince, and the Japanese designs were sometimes copied at secondhand from this; the so-called 'red dragon' of Meissen, introduced about 1730, was certainly so copied (3); at Chantilly it was called the 'Prince Henri pattern'. The style with 'Kakiemon' panels in a yellow ground (4) was almost certainly inspired from the same source. But however reached, the result has a very

(1) *Plate* 33A; (2) *Plates* 18-23, *Colour-Plate C*; (3) *Plate* 22; (4) *Plate* 18.

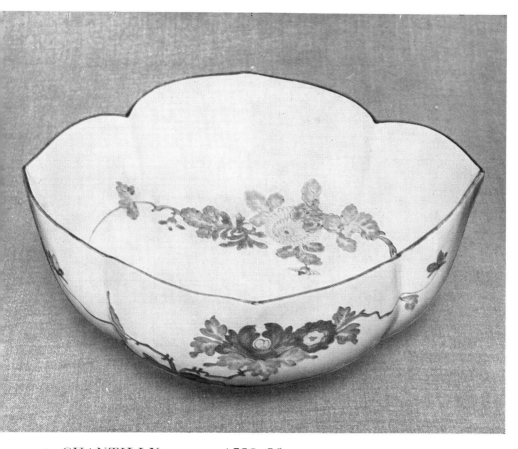

c. CHANTILLY. ABOUT 1730–35. MARK, A HUNTING-HORN
IN RED. DIAMETER, 8 IN.

Bedford, Cecil Higgins Museum
See page 14

distinctive quality. The handling of the designs—perhaps on account of the tin-glazed surface—shows an effect of fine black outlines and flat colour that is different from the manner adopted at Meissen. The colours themselves have a remarkable soft brilliance—the fine red usually has a mat surface, but the clear blue, pale yellow and turquoise-toned green colours are perfectly fused into the soft white glaze. The individual turn given to the Japanese figures is nowhere better seen than in the subjects of playing children (1), while the great dish here shown (2) is one of the finest of all its kind. The designs named by collectors after the bursting pomegranate ('*grenade*'), squirrel and banded hedge ('*haie fleurie*' and '*écureuil*'), the wheatsheaf ('*gerbe*') (3), quail or partridge ('*caille*', '*perdrix*') (4), and stork ('*cigogne*') are all adaptations from the '*Coréen*', simplified in the most exquisite taste. The playful slightness of the decoration and the absence of all symmetry find the Japanese and incipient Rococo taste at one.

The forms of the vessels, too, were largely suggested by the Japanese, but are equally marked by an entirely French sort of simplicity and supple rhythm. The melon or gourd (5) and pomegranate tea-pots and sweetmeat boxes, peach-shaped cups and dishes, and octagonal cups and saucers were directly derived from the Japanese, but are in the same taste as the simple lobed and fluted vessels (6), which like the graceful pear-shaped jug (7) and ogee drug-pots (8) show the influence of French faïence as well as of French silver.

The figure-modelling, which we may ascribe to the latter part of the early period, is often in this Japanese-French taste. Of the well-known pair of figures of a 'Chinese' man (9) and woman with panniers on their backs, the latter (which has been called 'typically French') was actually adapted from a Meissen vintage-woman; her companion is apparently original. A red-marked pair of the last-mentioned figures in the Victoria and Albert Museum (Fitzhenry Gift) shows a somewhat unusual cold-white glossy surface and painting which has been accused of being a later addition. Typical of the wares in the Oriental style may be mentioned the Chinaman holding a vase, in the Musée de Cluny(10), and a woman holding a pierced globe now adapted as a clock, in the Musée des Arts Décoratifs. Chantilly figures, however, are decidedly rare, and many of the knife-handles, *bonbonnières* and other 'toys' in the form of grotesque heads and animals commonly ascribed to the factory were more probably made at Saint-Cloud or Mennecy.

(1) *Plate* 23; (2) *Plate* 19; (3) *Plate* 21A; (4) *Plate* 20B; (5) *Plate* 20B; (6) *Plate* 21; (7) *Plate* 25; (8) *Plate* 24; (9) *Plate* 29; (10) *Plate* 28B.

The tin-glaze and glossiness mentioned above help to identify the Chantilly specimens, which probably date, for the most part, from about 1740 to 1750 (1). A set of knife-handles formerly in the Halinbourg Collection with an imbricated feather pattern (*'plume de perdrix'*) was preserved in a case with the Condé arms and is therefore a document for this class. A special fondness for dots and diapers may be noted as characteristic of this kind of Chantilly generally.

Figures that can be assigned to the later period are rare, though it was reported in 1787 that biscuit figures were being made (probably in hard paste). Plain white-glazed figures of a boy and girl holding cartouches were in the Chavagnac and Halinbourg Collections, one of them marked with the horn incised, and were probably late.

About the middle of the eighteenth century we find the influence of Vincennes making itself felt in a growing fondness for silver forms with foliations and scrollwork in the *Louis Quinze* style. Some two-handled vases of this kind (*'vases à oreilles'*) (2) have been erroneously attributed to Robert or Gilles Dubois, from the occurrence of similar forms in Vincennes; but they were more probably designed at the latter place and copied at Chantilly. Other forms in the same style seem to have been imitated from Meissen. Peculiar to Chantilly, early and late, is a knob formed of two or three wide-open flowers; bowls and tureens tended to be shallow, and amongst other peculiarities may be noted the form of globular-bodied jug (3) which, as in other early French porcelains (compare *Plate 56*), has a longer cylindrical neck than in German and other makes. Imitations of the Saint-Cloud applied flowers (probably early work) seem to adhere more closely to the body on account of the thick tin-glaze.

In the painting of this imitative period, copies of the later Meissen *'deutsche Blumen'* were not uncommon and were given a very individual and charming turn (4), but the flower-painting as often suggests Vincennes or Sèvres (5). The monochrome painting, such as the cupids in Boucher's style in dull bluish crimson (6), seems to date from the latter part of the monopoly period, when polychrome decoration alone was forbidden, but there are pieces with coloured and diapered grounds and reserved panels painted with animals, flowers and birds and even figures, which suggest that the Sèvres prohibition was not always observed; a quite exceptional vase in the Musée Condé, painted with a figure of Justice and a naked boy holding a shield with the lilies of France within Rococo scrollwork, and inscribed *'Fait à Chantilly par moi L. Ba . . . ce 4 novembre* 1756. *Petit Pinxit'*, is further evidence of

(1) *Plate* 28A, 51B, F; (2) *Plate* 27; (3) *Plate* 25; (4) *Plates* 25, 26; (5) *Plate* 27; (6) *Plate* 51A, 32.

this. A distinctive Chantilly ground-pattern was diapered with quatre-foils forming squares ('*quadrillé*') in blue enamel (1); so perfectly is this incorporated with the soft glaze that it nearly resembles the underglaze colour, which could not of course be used with the opaque tin-glaze. Some specimens with *gros bleu* ground and gilding (often of palm branches and birds) probably received this decoration at Tournay or Saint-Amand-Les-Eaux in the mid-nineteenth century (see p. 51).

In the last important period of the factory (about 1755 to 1780), simple and often very attractive wares were made in quantity. Plates in particular (so rare in Saint-Cloud and Mennecy) have survived in numbers, decorated chiefly in underglaze blue with slight patterns, the familiar names of which are sufficiently descriptive. The 'rose', 'tulip' and 'pink' ('*oeillet*'), which resemble monochrome versions of the Vincennes 'German' flowers (2), and a charming late Rococo-scrolled pattern with a bird and a border of festoons (3), are perhaps earlier than the rest. A 'rock' pattern in the quasi-Chinese style is not unlike that on some thick cups and saucers which are usually called Saint-Cloud. A saucer at the Sèvres Museum, gadrooned in the style of the latter but bearing the Chantilly mark, indicates the possibility of confusion. The common pattern with sketchy sprigs like ears of corn ('*à l'épi*' or '*à la brindille*') (4) is familiar in English, Tournay and Arras versions ('Chantilly sprigs'). The same patterns were sometimes done in blue enamel, dull crimson or (more rarely) manganese-purple or brown, when the mark was usually added in the same colour. A pretty design with a fountain ('*à jet d'eau*') (5) with trellis-work above it, and a rare slight landscape pattern, also in blue, may date from about 1760–70. The later patterns of the 'seventies and 'eighties may be distinguished by an increasing formalism, and as a rule the floral designs are of little interest. That of a service made for Louis-Philippe, Duke of Orleans (1752–85), with his crowned cipher and festooned borders of small flowers (6), must be late, though it seems always to have a tin-glaze; it usually bears the mark '*Villers Cotterets*', the name of the château for which it was made. (The same name occurs, but less often, on pieces with the 'Chantilly sprig', and the soft-paste so decorated, usually attributed to the Orleans factory on account of the heraldic 'label' it bears, is more likely to have been made for the Duke at Chantilly.) Another service has the arms of the Prince de Condé (7); and one, unusual in being painted in polychrome with bouquets of flowers, is marked with a large 'M' and is known as the '*Ménagerie*'

(1) *Plate* 30A; (2) *Plate* 31C; (3) *Plate* 30B; (4) *Plate* 33A; (5) *Plate* 31B; (6) *Plate* 30C; (7) *Plate* 33B.

service from its having been made for the house with that name in the park of Chantilly. The late Chantilly polychrome pieces usually have a brown or yellow edge. The small 'cornflower' (*'barbeau'*) sprig in green, blue and pink was probably one of the latest patterns introduced.

5

MENNECY, SCEAUX AND BOURG-LA-REINE

The porcelain and faïence manufacture protected by Louis-François de Neufville, duc de Villeroy, was established in 1734 and was at first conducted in Paris, in the rue de Charonne; it was transferred to Mennecy (Dept. of Seine-et-Oise) in 1748, and in 1773 to Bourg-la-Reine (Dept. of Seine). These three factories virtually form a single establishment. The productions of the first two bear the same mark, and those of the last-named, when not marked, can only with difficulty be distinguished from Mennecy. The porcelain of Sceaux near Paris (Dept. of Seine-et-Oise) also belongs to the Mennecy group, having been made, for a time at least, under the same management.

History: The Villeroy factory was from the beginning managed by François Barbin, *'faïencier'*, but little is known of his productions apart from his porcelain. The removal of the porcelain-factory from Paris in 1748 was doubtless due to opposition from the newly-privileged Vincennes. In 1751 Barbin was joined in the management by his son Jean-Baptiste; both died in 1765, in successive months. In the following year the factory was bought by Joseph Jullien and Symphorien Jacques, who had taken a lease of the factory at Sceaux three years earlier. After working both factories together for six years they gave up the Sceaux factory (in 1772) to Richard Glot (who in 1773 registered the mark 'SX') and abandoned Mennecy (in 1773) for new works at Bourg-la-Reine. Joseph Jullien died in 1774 and was succeeded by his son Joseph-Léon Jullien. In or about 1790 Charles-Symphorien Jacques joined his father, the above-named, who lived until 1798. It is probable that porcelain was made at Sceaux only during the period of Jullien and Jacques (1763–72). The factory remained in existence until 1806, but in its last years was chiefly a faïence-factory, presumably making cream-coloured ware.

Productions: The mark 'D V' (for 'de Villeroy') was used from the beginning on Villeroy porcelain. It was at first, apparently for a short time, painted, sometimes in blue (like Saint-Cloud), more often in red (like Chantilly). For the most part, however, it was incised in the paste, sometimes accompanied by the initials of throwers or 'repairers'.

It was not registered as a mark with the police authorities until 1773, when Jullien and Jacques at the same time registered the 'B R' of their new factory.

A number of other incised marks occurring on rather similar porcelain should be mentioned here. 'D, C, O' (1) and 'D, C, P' (separated by commas, as in the usual form of Mennecy mark), 'K O' (or 'R O') and 'F S' are typical. It has been suggested (though not proved) that these marks are those of Crépy-en-Valois or of Orleans (see below, pp. 23 and 24).

The early Mennecy or rue de Charonne porcelain was to some extent imitated from that of Saint-Cloud and Chantilly, but the material itself quickly assumed a distinctive character. The glaze of typical Mennecy is commonly very 'wet' and brilliant, its surface slightly wavy, but without the minute pitting of Saint-Cloud. In colour it is, at its best, a milky white. A sense of rivalry with Chantilly brought not only the early red mark just mentioned, but rare instances of the use of a tin-glaze (2).

The rather sketchy but charming painting of 'Japanese' and 'Chinese' figures and Kakiemon patterns of the earliest Mennecy is marked by a rather brownish red, and a strong green that shows a tendency to run, appears almost as if underglaze. The porcelain is in some of these early pieces rather yellowish in tone. An altogether exceptional Mennecy-Kakiemon specimen is the ewer and basin in the Pierpont Morgan Collection, which has a green ground. A pair of flower-pots in the Chavagnac Collection (No. 172), of Saint-Cloud form with mask handles and Chinese-Kakiemon painting, was marked with the 'D V' under a coronet in red. The rare Mennecy specimens with the Saint-Cloud blue *lambrequins* and the plain white pieces with plum-blossom (3) and other reliefs of the same derivation are to be distinguished by the glaze and a kind of feminine delicacy that shows itself in the forms of the tiny knobs of lids and in other ways. Blue-and-white knife-handles were found in excavations at Villeroy, but it is to be noted that they were not wasters. These early imitative wares evidently date from the first years of the factory. The mature Mennecy style of the following period was chiefly inspired by that of Vincennes. This was the time of the Vincennes-Sèvres monopoly, but the protection of the duc de Villeroy sufficed to ensure at least the continuance of Mennecy, though the order forbidding gilding was evidently respected, for we find edges painted instead with the characteristic Mennecy rose-pink and bright blue (4).

The forms were few in number and usually simple and graceful.

(1) *Plate* 41; (2) *Plate* 34A; (3) *Plate* 34B; (4) *Colour Plate E.*

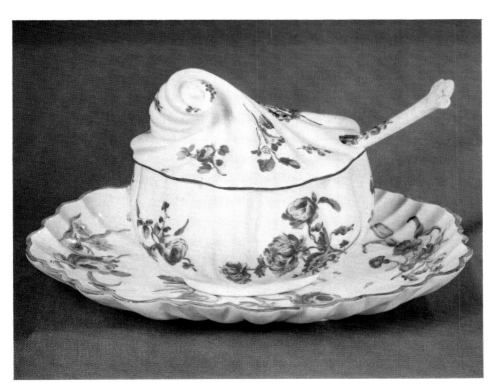

D. MENNECY. MIDDLE OF EIGHTEENTH CENTURY
MARK, 'D V' INCISED. HEIGHT, $5\frac{1}{4}$ IN.

Victoria and Albert Museum
See page 21

Straight-sided cups and saucers (1), globular and egg-shaped tea-pots with low foot-ring and double-curved handles (2) are characteristic among the useful wares. Close spiral reeding (3) was favoured for the numerous custard cups and the not uncommon basket-work mould-ing (4) took on a distinctive quality under the clear shining glaze. Among exceptional forms may be noted a graceful shell-shaped sugar-basin with volute cover (5), and some decorative pieces of modest pro-portions; 'Medici vases' (6) and a version of the Vincennes 'vase à oreilles' with foliated 'handles' are not uncommon. The applied flowers often garlanded about these are small and crowded closely together, and often of daisy-like form (7). The slight foliations moulded on vases and at the bases of handles and spouts were picked out in bright blue (8) or the characteristic Mennecy pink.

The modelling of the figures (which are often unmarked) was not always very accomplished but has an attractive simplicity comparable with that of Bow in English porcelain. Among the earliest are some small oriental figures painted in Kakiemon colours (9); a specimen marked in black was in the Chavagnac Collection (No. 167); other pieces of the kind are at Sèvres and in the Darblay Collection. In the best period, probably about 1760, one gifted modeller produced a series of 'round-groups' of children in the manner of Boucher (10), which rank among the best figures made in Europe. Not only beauti-fully modelled down to the smallest detail, they are also most deli-cately painted in soft blues and pinks. Of the same date and quality is a figure of a youth attached to a sweetmeat dish (11), while another (12), in the Victoria and Albert Museum, in its colouring and simplicity, again recalls the English figures made at Bow. Equally admirable are some white-glazed models, such as a full-length figure and a bust of *Louis XV*, and a *River God* (13) from a model by Nicolas François Gauron, who was employed at the factory in 1753 and was later at Tournay and Chelsea. A version of this figure attributed to Vincennes and signed 'Gauron 1754' is mounted with a *Naiad* and some porcelain flowers on a clock in the Salomon de Rothschild Be-quest at the Louvre; another specimen, in a different paste, at the Victoria and Albert Museum, is marked 'D V' incised, and also 'D V' and 'B R' (?) in blue and was perhaps made in biscuit at Mennecy, before the removal to Bourg-la-Reine, where it was glazed. Other white-glazed figures include a 'D V'-marked standing *Diana* in Clas-sical style at the Sèvres Museum.

(1) *Plate* 42B; (2) *Plate* 43A; (3) *Plate* 34C; (4) *Plate* 34D; (5) *Colour Plate D*; (6) *Plate* 39; (7) *Plate* 40; (8) *Colour-Plate E*; (9) *Plate* 44A; (10) *Plate* 46; (11) *Plate* 45A; (12) *Plate* 47A; (13) *Plate* 48.

FRENCH PORCELAIN

Of undetermined date but perhaps made rather before 1750 (1) are some fantastic long-legged figures from the Italian Comedy, a charming *Beggar* in the Georges Feray Collection, and languid young men with open-necked shirts; we may note the artless rendering of longitudinal folds in the costumes of these. Also early are some figures of grotesque dwarfs (2) recalling the 'Callot figures' of Meissen and other German factories. Among the other (as a rule small) figures may be mentioned the *Monkey riding on a hound* (a specimen in the Grollier Collection is marked 'De Villeroy' incised in full), copies of Meissen shepherdesses and *Dianas* and men with dogs, and a pretty version of a Meissen-Chinese figure of a squatting *Monkey*. Two unusually large figures of seated *Peasants* attributed to Mennecy are in the Musée de Cluny and a large *Chinaman* is in the Musée des Arts Décoratifs; these are not unlike some figures attributed to Tournay.

Imitations of the Chantilly and Vincennes pierced perfume-pots are often distinguishable by a purplish-brown used for the flower stems, and a brown and a yellowish green on the rockwork bases (3), which are sometimes smeared with a medley of colours. The bases of figures often show similar treatment.

The biscuit figures belong to the Jullien and Jacques period and are comparatively uninteresting. The marks 'J Mo' and 'Mo' sometimes occur on them and are those of two brothers, modellers or 'repairers', named Christophe and Jean (or Jean-Baptiste) Mô, first employed in 1767 and 1768 respectively; the last-named continued to work at Bourg-la-Reine. A glazed and coloured figure of a drummer formerly in the Chavagnac Collection was signed 'J Mo', as is a biscuit figure of a boy with a telescope, in the Grollier Collection, which also includes in marked biscuit a group of two girls with garlands, one above the other, a standing figure of a boy with flowers held out in each hand (the type of face with broad nose and thick lips is noteworthy), a 'D V'-marked relief of *Louis XV*, and a well-modelled large group of musicians marked 'B R Mo'. A group of five naked boys caging a bird (4), in the Victoria and Albert Museum, is also marked 'D V Mo'.

The enamel painting of the best period was not strictly original in invention, but rather a sensitive individual rendering of borrowed motives; it was conspicuously cool and fresh in colour. The characteristic pink and bright blue are seen in many pieces and were much used in versions of the naturalistic '*deutsche Blumen*' as modified at Vincennes (5). Birds (6) and figures in slight landscapes (7) are again in the style of Vincennes-Sèvres and also recall the Sceaux faïence. All

(1) *Plate* 45B; (2) *Plate* 44B; (3) *Plate* 38; (4) *Plate* 49; (5) *Colour-Plate D, Plates* 35-39, 41; (6) *Plate* 43A; (7) *Plate* 42B.

these are sometimes in a light crimson or blue enamel monochrome; in other pieces a brownish-green tonality is noticeable. Rare specimens exist (d'Yanville Collection No. 200) with *quadrillé* grounds and reserved panels, in Chantilly style, and *caillouté* green grounds are also known. In general, precise dating is difficult, and except where marked, Bourg-la-Reine cannot easily be distinguished from Mennecy. A rare lobed tureen dated 1767, in the Sèvres Museum, is plain white and unfortunately gives no help, but indicates the late survival of the Rococo style, as does a sugar-basin (1) painted with birds in rather pale Mennecy colours, at the Victoria and Albert Museum, marked 'B R' incised. Among the latest productions were evidently those painted with the Chantilly sprigs ('*à l'épi*').

The Sceaux porcelain is rare but not of distinctive quality, closely resembling Mennecy of the period of Jullien and Jacques. Occasionally beautiful flower-painting in Sèvres style, as on a wine-cooler and flower-pot (2), in the Victoria and Albert Museum, cupids in pink monochrome, and some bird-painting, are recognisably by the same hand as that on the famous Sceaux faïence. Pieces decorated with 'Chantilly sprigs' are not uncommon, and flower-painting in blue enamel monochrome (again like Mennecy) is often found.

Many snuff-boxes, often in the form of animals (3) or moulded in relief with flowers coloured over (4), scent-bottles and knife-handles, are commonly ascribed to Mennecy, but very few are marked, and some may well have been made at Crépy-en-Valois (Dept. of Oise), where a factory was started in 1762 by a Mennecy modeller named Louis-François Gaignepain and made a feature of 'toys' of this kind. Kakiemon-painted knife-handles and cane-handles (5) marked 'D V' in red are known (they are similar to the earliest wares described above), and some boxes moulded in the form of a miniature chest (Victoria and Albert Museum (6) and Sèvres), painted with small flowers, are among the rare marked and documentary pieces. The Mennecy brown and yellowish-green may perhaps be taken as an indication of the origin of some of the small animals, but others were certainly made elsewhere. The snuff-box in the form of rabbits here figured (7) bears flower-painting on the lid unlike any found on marked Mennecy.

Of undetermined origin, in particular, and in question as possible Crépy work, are the pieces bearing the unexplained incised marks 'D, C, O' and 'D, C, P' (8), 'K O', 'F S', etc. That they were not made at Mennecy seems to be indicated by the *incised* criss-cross used to pro-

(1) *Plate* 43B; (2) *Plate* 42A; (3) *Plates* 50E, F, G; (4) *Plate* 50H; (5) *Plate* 51A; (6) *Plate* 50F; (7) *Plate* 50F; (8) *Plate* 41.

duce the basket-work pattern (as on a cup at Sèvres marked 'D, C, O'), which at Mennecy was usually done by moulding. Figures with these marks have been confidently ascribed to Crépy on the evidence of two small figures, of which one is marked 'Crépy' in full, while the companion is marked 'C. P.'. It is argued that on the analogy of this and of 'D, V' for 'de Villeroy', 'D, C, P' could stand for 'de Crépy'. 'D, C, O' and the other marks, however, are still unexplained, unless by a questionable analogy they are held to be Orleans work, as proposed below. The Crépy account-books include groups described as '*sur terrasse*' and 'D, C, O'-marked specimens agreeing with other descriptions in the books are known to exist. Some of the figures with the same mark (such as a biscuit group in the Grollier Collection of a man with a shepherd girl seated above him) are of fine quality. Others (such as a group of musicians in the Pierpont Morgan Collection) are awkward in composition. The incised signatures '*Louis*' and '*Pierre Renau*' occurring on kindred pieces in the Franks Collection (British Museum), of rather crudely modelled facing figures (1) not unlike some Mennecy groups suggests that the 'D, C, O'-marked pieces may have been made at Orleans, where 'repairers' of these names, and a Mennecy modeller named Bernard Huet, were employed. In any case, it seems certain that these classes were inspired by some person or persons at one time connected with the Mennecy factory.

(1) *Plate* 47 B.

6

VINCENNES AND SÈVRES

History: The National Manufacture is usually held to have begun in 1738, when Gilles and Robert Dubois, runaway workmen from Chantilly claiming the secret of porcelain-making, were engaged by a nobleman named Orry de Fulvy and installed in the disused royal château at Vincennes, not far from Paris. After paying out much money, including subscriptions from the King, without result, Orry de Fulvy discharged the Dubois in 1741, but continued to finance the experiments of François Gravant, who had accompanied the brothers from Chantilly and had taken advantage of their frequent drunkenness to extract such secrets as they possessed. Though aided by other workmen from Chantilly and from Saint-Cloud, Gravant does not seem to have been entirely successful until 1745. In that year a company was formed in the name of Charles Adam, with a capital of over 90,000 livres, and the first of its several privileges was granted to the factory. This accorded it the exclusive right for twenty years to manufacture 'porcelain in the style of the Saxon, that is to say, painted and gilded with human figures'. It is clear that from the first there was present a fear of the Meissen competition with French industry or envy of the Meissen commercial success. The privilege was perhaps obtained with the help of Orry de Vignory, brother of Orry de Fulvy, who held the office of Director-General of Buildings, Arts and Manufactures, but was disgraced in the same year. He was succeeded as Controller of Finances, by Jean-Baptiste de Machault, a lover of art whose intelligent interest largely determined the direction of the factory until his departure from the post in 1754. In 1747, he issued a new order in favour of Vincennes, expressly forbidding other manufacturers to make porcelain, and more particularly their engagement of Vincennes workmen, threatening the workmen themselves with severe penalties in case of desertion.

A distinguished chemist, Jean Hellot, was appointed by Machault in 1745, and the royal goldsmith Jean-Claude Duplessis and the enameller Jean-Adam Mathieu were respectively charged with the

Conflicting accounts have been given of the history of the Sèvres factory. That given here is based in the main on that of Chavagnac and Grollier.

supervision of modelling and decoration. About the same time Hendrik van Hults (or Hulst) was made adviser in matters of style and probably had great influence. Boileau de Picardie was from this same date in effect in charge of the non-technical side, including the accounts, and remained director throughout the greatest period of the factory until his death in 1772.

François Gravant continued to supply the paste and glaze until his death in 1765, when he was succeeded by his son Louis-François; one Humbert Gérin (or Guérin) seems also to have been in possession of the secret in 1747. A process of gilding was bought for a large sum from Frère Hippolyte, a Benedictine monk. Coloured enamels not previously at command were prepared by Hellot and by some of the painters and workmen under him, amongst them Louis-Pierre Massuë, Jean-Mathias Caillat, Pierre-Antoine-Henri Taunay and Bailly; the last-named was from 1753 in charge of the colour-department. Millot, who had joined the staff in 1740, was in charge of the kilns. About 1750 over 100 workmen in all were employed.

Jean-Jacques Bachelier, one of the most influential figures in the history of the manufacture, was appointed in 1748. In his account of the early period of Vincennes he claims to have replaced Mathieu from the date of his appointment though he seems not to have been actually made Art Director until 1751.

Orry de Fulvy died in 1751 and the repayment to his executors of the value of his shares in the Charles Adam company necessitated its dissolution and the formation of another, this time in the name of Eloi Brichard. A new order was issued in 1752, passing on the former privilege to this company, whose capital of 800,000 livres came largely from the *fermiers* of taxes, though the King himself subscribed a fourth of the sum. (These figures are stated by Auscher, apparently in error, as 600,000 and a third respectively.) In the following year, 1753, was issued another order confirming the privilege granted to the company and adding new and ferocious restrictions on rival activity, forbidding the manufacture elsewhere in France, not only of porcelain, but even of white pottery decorated in colours. The same order still further restricted the liberties of the workmen. The mark of the crossed 'L's'—the royal cipher—was in this order for the first time declared to be the factory-mark, though it had certainly been used earlier. From this time, however, date-letters began to be added to it, and the factory was thenceforward formally known as the '*Manufacture royale de porcelaine*', though the interest secured for it by Madame de Pompadour had made it for several years a royal one, in fact, if not in name. The order of 1753 marks the end of the first period of the factory.

In 1753, too, came the proposal to move the factory to Sèvres, between Paris and Versailles, close to Madame de Pompadour's new château at Bellevue, where a large and inconvenient building resembling a mansion, with a summer house for the King, began to be erected for the purpose, to be finished and occupied in 1756. The establishment rapidly fell into debt, owing something like 500,000 livres in 1759, when its creditors proposed to sell up its effects. In that year, probably at the suggestion of Boileau, who wished to escape from the control of the Brichard Company, the concern was finally bought by the King and was thenceforward maintained by a subvention. The change was confirmed by an order of 1760 transferring to the King the privileges previously enjoyed by the Company. The most important event in the period of the Brichard Company (1753 to 1759) was the definitive appointment in 1757 of the sculptor Etienne-Maurice Falconet, who remained until his departure for Russia in 1766, when Bachelier succeeded him as head of the modelling department.

From the first the chemist Hellot had not lost sight of the original intention to produce true hard porcelain like the German, and in 1753 an opportunity to learn something of its making occurred when Paul-Antoine Hannong's Strasburg factory was attacked under the order of that year. Hannong in defence offered to dispose of the secret, but Boileau declined to purchase in the absence of the essential indication of a French source of supply of *kaolin*. But he extracted, apparently, some information as to the materials used. In the end, Hannong's Strasburg porcelain-kilns were ordered to be demolished and he left the country to found the manufacture of Frankenthal in the Palatinate. In 1753–54 two 'arcanists', said to have come from Strasburg, C. D. Busch and Stadelmayer, cost Vincennes some 12,000 livres for experiments in hard paste, and on the death of Paul Hannong in 1760, Boileau was sent to Frankenthal to treat with his son Joseph-Adam, who seems to have asked too large a price; the latter's brother Pierre-Antoine, however, after some delays, made convincing experiments and in 1763 was granted an annual allowance, which he later declared was never paid in the lifetime of Louis XV; these experiments cost the factory more than 14,000 livres. A year later Busch, having been manager and 'arcanist' at Kelsterbach, was allowed to make further experiments, again without result. In 1767, fruitless negotiations for the engagement of the Nymphenburg manager, J. K. von Linprun, took place through the French Ambassador at Munich, Hubert de Folard, and about the same time negotiations were started by Count Gronsfeldt of Weesp for the amalgamation with Sèvres of his factory, where hard paste was being made with the help of German workmen.

An apparent change of attitude had come in 1766 when Bertin,

Minister of Fine Arts, professing a desire to encourage the national porcelain industry, issued an order authorising the making at other factories of porcelain 'in imitation of the Chinese, with such ingredients as the makers consider suitable', the sole condition being that every piece should bear a mark registered with the police authorities. For Sèvres, however, was reserved '*l'application d'or, la peinture en mignature et en fleurs coloriées, les fonds en couleur et enfin le travail de la sculpture*'. The intention was undoubtedly to stimulate the search in France for the materials of hard paste, ultimately for the benefit of the Royal Manufacture.

The composition of hard paste seems to have been actually well-known to French scientists at this time, and the chief obstacle to its manufacture was the absence of a French source of *kaolin* and *petuntse*. The *kaolin* of Alençon used by Brancas-Lauraguais in experiments (about 1764, or earlier, to about 1768) had not proved satisfactory, producing a greyish porcelain, and the search for a finer quality occupied the attention of Pierre-Joseph Macquer, who had been appointed chief chemist and assistant to Hellot in 1759. This was eventually found in 1768 at Saint-Yrieix, near Limoges. Though the deposits there seem to have been known to a chemist named Guettard for some time before, and were actually used in earthenware or soft paste at Orleans, a picturesque account has been given of their 'discovery' by Macquer and Millot, his kiln-master. In this account it is said that a promising sample was first of all sent to Sèvres by the Archbishop of Bordeaux, whose help had been invited by Bertin and who had obtained the mineral through a local apothecary named Vilaris, who in turn had received it from Darnet, a surgeon of Saint-Yrieix. (Darnet, however, had apparently no notion of its importance and his wife had been in the habit of using it for cleaning-purposes.) With the sample thus obtained was made a little figure of the *Infant Bacchus*, still preserved in the Sèvres Museum. Vilaris refused to reveal the site whence it came save on payment of an excessively large price and Bertin thereupon instructed Macquer to conduct a personal search for it. Vainly touring Orleans, Blois, Tours and other places they found near Biarritz a material somewhat resembling *kaolin*. Vilaris, learning of this discovery and fearing to lose all reward, changed his tactics and offered to conduct them to the site. On their reaching it, the son of the proprietress there at first threatened to call out the local population to mob them if they proceeded, but eventually gave way and allowed a consignment to be despatched to Sèvres. This was in November 1768. After highly successful trials, in the following year, the deposits were bought by the King. Macquer and Etienne-Mignol de Montigny (who had succeeded Hellot on his death in 1766) sub-

mitted a paper to the Académie des Sciences in 1769, pointing out with pride that the new porcelain was made entirely of French materials, that it contained 'no frit, alkali, or lead or other metallic substance', besides having the qualities of refractoriness, hardness and durability characteristic of true porcelain. Vilaris received, after all, a reward of 15,000 livres. There is a well-known story of the test made by Macquer and Montigny in December 1769 before Louis XV, when a vessel made of the new porcelain was proudly set to boil over a spirit-lamp, but unfortunately cracked, to the King's amusement. A further experiment, later in the day, was, however, successful.

The new porcelain thus made in 1769 was marked with a crowned version of the crossed 'L's' and named the '*Porcelaine Royale*' to distinguish it from the '*Porcelaine de France*', as the *pâte tendre* continued to be called. Its manufacture on a considerable scale did not begin until 1772, by which date several other hard-paste manufactures were in operation in France, such as those of P.-A. Hannong at Vincennes and Vaux, and in the Faubourg Saint-Denis in Paris, and one at Limoges itself. The order of 1766 had in fact dealt a severe blow to the Sèvres monopoly. Even the restriction regarding sculpture was in 1769 relinquished in favour of the hard-paste biscuit made at Lunéville and called '*pâte de marbre*', on condition that the productions were sold as '*terre cuite*'. The year 1772 (which was also the date of Boileau's death) thus marks the end of another period. Thenceforward difficulties of one sort or another constantly hampered the royal factory, which was battling for its 'rights' against an increasing body of competitors.

Boileau's successor Parent energetically proceeded to develop the hard-paste branch, engaging hands from Germany for the purpose, but after six years was found to have misappropriated funds and with his accountant Roger was imprisoned. The deficit was no less than 247,000 livres. Nevertheless the factory was more active than ever before; the number of workmen reached its highest total—nearly 400 —and orders poured in from all quarters, as from Russia (for Catherine II) and from other foreign notabilities as well as from the King himself. The sculptor Louis-Simon Boizot was engaged in this period (1774) to take charge of the modelling department, where he remained until 1802.

Régnier succeeded Parent in 1778 and in the following year attempted to check the growth of rival factories by a further order, which was naturally ineffective since several of them were under the protection of royal personages. Bertin's failure to enforce the order was perhaps the cause of his supersession by the Comte d'Angivillier in 1780. From this date to the Revolution d'Angivillier continued to

conduct the factory on economical lines and with a conscientious regard for its reputation, though its great time was evidently over. Still another order, in 1784, attempted to control the factory's competitors and twelve proprietors were notified. While authorising the manufacture of the simpler table-wares it required the rival proprietors (with the exception of those of Sceaux and Chantilly) to remove their factories to sites at least fifteen leagues from Paris. This order was naturally ineffective in face of the general disregard of privileges at the time, and in 1787 four Paris establishments—those of the rue Thiroux, of Clignancourt, the rue de Bondy and the Faubourg Saint-Denis (respectively protected by the Queen, by Monsieur, by the duc d'Angoulême, and by the Comte d'Artois) were by a fresh order granted permission to make the classes of objects previously reserved for Sèvres, with the exception of certain *'ouvrages de grand luxe'*, such as pictures in porcelain, pieces with gilt grounds, and vases and figures exceeding eighteen inches in height not counting the bases. The other factories were to be tolerated on proof of the perfecting of their methods and products. The concession marks the end of the Sèvres monopoly. Other noteworthy events of this period were the appointments of the painter Lagrenée *le jeune* as Art Director (1785) in association with Bachelier, and of Jean-Jacques Hettlinger, a Swiss geologist, made Inspector and Assistant-Director in 1784, and the purchase in the last-mentioned year of the Limoges factory of Grellet and Massié to supply hard paste 'in the white' for decoration at Sèvres.

Louis XVI (succeeded 1774) was too much occupied with political and financial difficulties ever to give as much attention to the manufacture as his grandfather had done. More and more in debt as 1790 approached, the factory was scarcely able to pay its workmen, and in that year a group of financiers offered to buy it, but the King refused and in a famous phrase re-affirmed that the factory was maintained at his own expense—*'Je garde la Manufacture de Sèvres à mes frais'*. There were no funds, however, and Sèvres virtually ceased to be a royal factory on the abolition of the monarchy in August 1792.

Little of interest to the student of porcelain took place in the first years of the Republic. Hettlinger, co-director with Jean-François-Hylaire Salmon and François Meyer in 1796, was in effect in charge for most of the time. In 1800 Napoleon Bonaparte appointed Alexandre Brongniart to the administration and technical leadership, and the modern period began. By far the most significant event at this time was Brongniart's decision, soon after his appointment, to abandon the manufacture of soft paste as too costly.

Productions: The Vincennes and Sèvres porcelain of the eighteenth century falls naturally into three periods as already indicated. The first

or early Vincennes period' dates from the beginning to 1753, when the Brichard Company assumed the title of '*Manufacture Royale*' and the use of date-letters began. The styles of this period, however, survived in occasional work of later date. In the second period (1753 to 1772) was produced the finest and most accomplished *pâte tendre*, the porcelain with which the name of Sèvres is most honourably and familiarly associated, though for the first three years of the period the factory actually remained at Vincennes. After 1768 the discovery of the materials of hard paste in France brought many rival establishments, and the complete supersession of the *Louis Quinze* style by the *Louis Seize* and Neo-Classical robbed the modelling and painting of much of their vitality and charm. It should be noted that from 1772 to 1800 both hard and soft paste were made concurrently.

The very earliest Vincennes has never been certainly identified; it was unmarked and may be presumed to have resembled Chantilly since the workmen came thence. Bachelier in his account of the early history of the factory stated that before his appointment in 1748 the decoration was only a 'crude imitation of the Japanese'. Chavagnac cites an early lobed 'Kakiemon'-decorated piece, which may, however, to judge by its handle, have been copied from the Japanese by way of Meissen. A two-handled sauceboat of lobed outline in the Sèvres Museum is painted with stiff flower-sprays in the same Japanese style; both probably date from before 1748 and are perhaps examples of the style referred to. A very early dish in the same Museum is painted with a version of the Meissen 'yellow tiger' pattern combined with the 'botanical' or 'German' flowers of the same origin, and the latter were in fact frequently copied on pieces of this period; the rival Meissen porcelain was constantly in mind. The flowers as rendered by the French artists show the utmost delicacy and refinement; figures in landscapes inspired from the same source may be seen on some rare specimens in the Sèvres Museum, such as a small jug with 'Watteau' subjects and a large one with a sea-piece; a large saucer-dish in the same collection—figured by Lechevallier—is painted with a view of the Vincennes factory by Etienne-Henry Le Guay. The ten specimens figured here (1) are beautiful examples of these very distinct Vincennes versions of the Meissen Rococo themes. Herold's Meissen *chinoiseries* were apparently never copied, but Boucher's 'Chinese' figures were charmingly adapted in a rare type (2). The favourite *Galanterien* of the German factory—the snuff-boxes, *étuis* and scent-bottles—were the inspiration of Vincennes examples with figure-painting of an incom-

(1) *Plates* 53A, 54–59; (2) *Plate* 59.

parable grace (1). A type of border with flowers moulded in low relief was also of Meissen inspiration but the designs themselves were original, and with the raised plum-blossom (2) copied from the Chinese or from Saint-Cloud and used in the same way, remained a favourite decoration for some time. Both acquired an attractive quality in the exquisitely pure white paste; the reliefs seem to float in the pellucid glaze as in no other porcelain. Underglaze blue painting was hardly attempted, though a rare cup and saucer with a foliated mark of crossed 'L's' (Mark No. 3 on p. 54), at the Sèvres Museum, is so decorated with floral sprays and bold toothed borders in a violet-toned colour of striking quality.

The ideals which inspired the new and more original styles are well indicated in a letter from Hults to Boileau dated 21st September 1751: '*La diversité des goûts est l'ange tutelaire d'une manufacture qui roule sur des objets d'agrément: ce qui ne plaît aux uns plaît aux autres. En fait de porcelaine surtout, les dessins les plus bizarres et les plus chimériques l'emporteront sur les dessins les plus élégants et les mieux raisonnés. Que l'on fuie le lourd et le trivial, qu'on donne du léger, du fin, du neuf et du varié, le succès est assuré . . . Gentillesse, nouveauté, variété, doivent être sa devise. Qui dit gentillesse dit choses légères. On ne lui demande que des éternuments de son génie semblables à ceux d'une jolie femme: c'est à dire riants et agréables.*'

By 1750 at the latest Gravant had at command a nearly perfect soft-paste material, made by methods almost incredibly laborious. Sand from Fontainebleau, salt and saltpetre, 'soda of Alicante' and alabaster were fritted for about fifty hours and ground up for about three weeks, dried and crushed again, and mixed with clay and fragments of paste from the throwing room. Soap was added to make the mixture plastic. Like all soft pastes it was unstable in the kiln, but when successfully fired it combined all the good qualities of the earlier French porcelains; it was whiter than they, but never cold in tone.

The simpler Vincennes shapes included the characteristic French jug with long cylindrical neck, large-bodied jugs with short neck and small mouth, ice-pails and other vessels with lobed and wavy edges, '*vases à oignons*' with cupped mouths, and many others, all of them with a peculiarly French suavity and grace. The scrolled and shell ornament of the later Rococo is seen in some beautiful sauce-boats (3) and vases. The simpler forms survived for several years and were often used towards 1760 at the same time as some large and over-elaborate vases of types more often associated with the later period of Sèvres. Of these latter may be mentioned the well-known

(1) *Plate* 51D; (2) *Plate* 60A; (3) *Plates* 60B, 61B.

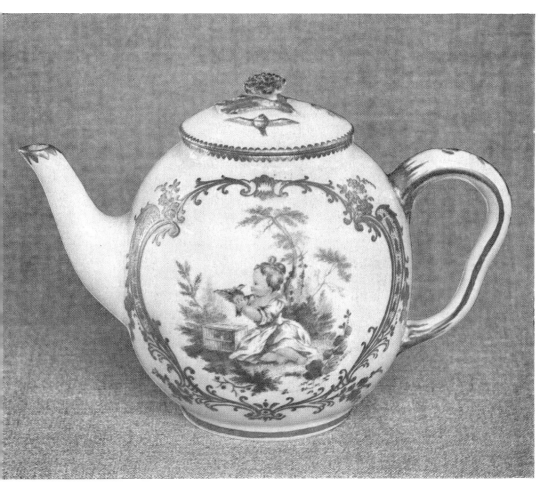

F. VINCENNES. DATED 1754. MARKS, IN BLUE, CROSSED 'L'S'
ENCLOSING 'B' (FOR THE YEAR 1754) AND THE MARK OF THE
PAINTER VIEILLIARD. HEIGHT, $3\frac{7}{8}$ IN.
Victoria and Albert Museum
See page 33

'*vaisseau à mât*' and the vases with elephant handles and the like, of which some of the most imposing specimens are in English collections —at the Victoria and Albert Museum (Jones Collection), Hertford House (Wallace Collection), and in the royal houses of Buckingham Palace and Windsor Castle.

In the decoration, the Meissen style of flower- and figure-painting was quickly transformed into something distinctively French: certain formal scrolled motives and borders on handles and spouts are characteristic here (1). Monochrome painting in crimson or green (2) followed the German but was softer in colour and touch; the intense blue monochrome (perhaps first used by André Vincent Vieilliard but adopted also by other painters at the factory) was a novelty in colour and with the flesh tones added ranks as one of the chief early Vincennes inventions (3). A cup and saucer painted with buildings in the rare green and black monochrome (remotely suggested by Meissen) is in the Musée des Arts Décoratifs, Paris, which is especially rich in Vincennes and early Sèvres of the simpler and better kind. The beautiful gilding was occasionally used quite alone (4) in what was virtually a new style, but its quality was nowhere better seen than in combination with the first of the famous ground colours, the dark and pleasantly uneven *gros bleu* (5), introduced apparently as early as 1749. Mutel's 'silhouetted' birds should be mentioned in this connection. The painting of figures and birds in landscapes by Vieilliard, François Joseph Aloncle, Philippe Xhrouet, Etienne Evans, Edmé Gommery, Jean-Pierre Le Doux and others shows an entirely new style, light and unlaboured (6), and probably due to the instruction of Bachelier and Jean-Baptiste-Etienne Genest, who supplied designs for the painters to copy and adapt. By a concession unique in the practice of the larger factories in the eighteenth century, the painters were allowed to append their signature, in cipher, to the factory-mark.

The avowed intention to rival Meissen naturally implied a wish to make porcelain figures, though there are very few that can be ascribed to the period before 1750. But rivalry was early shown in still another direction. The modelled flowers made in imitation of the 'Saxe' were at first the most important part of the factory output. The most famous bouquet, of no fewer than 480 separate blossoms, was sent in 1748 or 1749 by the Dauphine Marie-Josèphe to her father the Elector of Saxony, evidently with the intention of showing him that Vincennes could equal Meissen; this bouquet was mounted in ormolu with a glazed white vase and two glazed white groups, all of the

(1) *Plates* 58A, B; (2) *Plate* 61A; (3) *Colour-Plate F*; (4) *Plates* 60A, 63; (5) *Plate* 62; (6) *Plate* 61A.

Vincennes porcelain. Another famous occasion was the reception of the King by Madame de Pompadour in a conservatory furnished with these flowers, perfumed to heighten the illusion. Tulips, lilies, daffodils and hyacinths were made, as well as the more usual roses, and were of full size and coloured after nature, suitably stylised. They enjoyed a great vogue, and in 1749 formed five-sixths of the total sales value. These particulars of the flowers and other objects sold in the early period appear in the well-known *Livre-Journal* of Lazare Duvaux (1748 to 1758). Smaller flowers were applied in the Meissen manner to *pot-pourri* vases and pastille-burners, etc., of which some beautiful specimens survive (1).

From the first the figures were original models. Bachelier stated that up to 1749 coloured figures only were made, and that after his introduction of biscuit in 1751 these were but rarely done. A coloured figure entitled *La Source*, with ormolu mounting by Duplessis dated 1761, in the Thiers Collection (Louvre), may be an early model coloured at a later date. This figure is sometimes called a *Naiad* and ascribed to Louis Fournier, who is recorded to have modelled some works with this name (1747), which would, however, be better applied to the naked figures, such as one mounted with a companion *River God* (signed 'Gauron 1754') and some porcelain flowers on a clock in the Rothschild Bequest at the Louvre; the *River God*, however, occurs also in Mennecy porcelain (see p. 21). The *Naiad* was adapted into a figure of *Diana*, and there exists another model of the same goddess sleeping (Victoria and Albert Museum (2)). Of the modellers of the early figures the names of Goubert, Deperrieux (or Depiéreux), Patouillet (or Patrouillot), Laurent, Henri Bulidon, Chanou *aîné* and Henri-Florentin, Louis Fournier, Hubert and Blondeau are recorded by Bourgeois and Chavagnac.

These distinct and charming early glazed white figures include a series of eight *Enfants d'après Boucher* modelled by Blondeau (1752–53—*La Petite Fille à la cage* or *La Douleur de Babet* (Sèvres Museum), and the companion *Corydon* or *Le Porteur d'Oiseaux* (also at Sèvres), *Le Jeune Suppliant*, *La Danseuse Boucher*, and *Le Joueur de Musette*, all probably inspired by a comedy of Madame Favart entitled *La Vallée de Montmorency*, produced in 1752; *Le Moissonneur* and *La Moissonneuse* (Chavagnac Collection), and *Le Jardinier au tablier* (Sèvres Museum). Also dating from 1753 are *Le Jaloux* by Van de Voorst or Vandrevolle (terra-cotta model at Sèvres Museum; glazed white specimen in the Pierpont Morgan Collection) and the beautiful *Mangeuses de Raisins* (formerly in the Fitzhenry Collection) and *Venus crowning*

(1) *Plates* 52, 53B; (2) *Plate* 65B.

Cupid, which last Bourgeois rather surprisingly identifies with the model entitled in the records *L'Heure du Berger*, though the name would be more aptly applied to the group (sometimes called *Venus and Adonis*) of a man approaching a sleeping girl with a basket of flowers (1), of which there are two examples at the Victoria and Albert Museum, one with a turquoise-coloured glaze, perhaps a later addition. The artist who modelled these attractive groups has not been identified; but the *Europe and Africa* (formerly in the Chavagnac Collection) is known to be by Le Boiteux after Jean-Baptiste Oudry. This also dates from 1753, like the famous *Leçon de Flute* after Boucher, much reproduced in later years. The contemporary lists mention numerous figures of birds and animals, including groups by Blondeau after Oudry and paper-weights in the form of sheep. Some birds on pedestals, painted in colours, still show the Meissen influence.

The biscuit porcelain invented by Bachelier at some time before 1753 (when it is first mentioned by Duvaux) soon began to displace the other. It is recorded that in 1754 Madame de Pompadour, who already had the eight *Enfants Boucher* in glazed porcelain, ordered them in biscuit. But glaze continued to be added occasionally, as on two paper-weights in the form of naked boys amongst marine paraphernalia which were presented to Machault on his appointment to the Admiralty in 1754; these were inherited by his descendant Mme Chavagnac and are now in the Musée des Arts Décoratifs. They were perhaps modelled by Louis-Félix de La Rue, who in 1755 adapted for porcelain some forty statuettes of children after *Il Fiammingo* (François Duquesnoy, *Flamant*), and in 1757 modelled some charming groups of little boys playing with a fish and with a conch-shell, of which glazed specimens are in the Victoria and Albert Museum (Jones Collection) (2).

No attempt can be made here to enumerate the very many models created in the forty years following the introduction of biscuit; they are fully set out by Bourgeois (without reference, however, to any documents), and in Chavagnac and Grollier, whose lists are the more valuable in giving dates and artists' names only where these appear in the factory records. There was present from the first a temptation to use biscuit porcelain for the reproduction of monumental sculpture, and on this account the later Sèvres figures, however finely wrought, are seldom as interesting as those of Vincennes or of the German factories. Many of the models of Falconet were in fact reproduced indifferently in biscuit and in marble.

It should be noted that in spite of the fame of the early Sèvres

(1) *Plate* 64; (2) *Plate* 65A.

models only a small number were actually produced in the period 1760 to 1770, and sales of biscuit porcelain were (as Lechevallier-Chevignard has pointed out) relatively few.

Falconet was not actually appointed until 1757, but according to Chavagnac and Bourgeois he had previously (1755) modelled the beautiful figure of Mme de Pompadour in the character of *L'Amitié* or the *Goddess of Friendship*, of which there is a specimen at the Sèvres Museum (another was in the Pierpont Morgan Collection), which shows something of the same porcelain quality as the earlier glazed groups; the same model is, however, identified by Réau with '*L'Amitié au Coeur*', dating from 1764–65. The influence of Boucher was still evident in the biscuit groups of children entitled *La Loterie* and *La Lanterne Magique*, by Falconet, as well as in the *Little Stonemason* and *Laundress* and other models by Jean-Baptiste de Fernex and Suzanne. The important *Leda* (1764) (1) was also modelled by Falconet after Boucher. But most of Falconet's work in his nine years at the factory was entirely his own. The *Cupid* (1758) and the companion *Psyche* (1761) as children (known as the '*Garde à vous!*' pair), *Le sabot cassé* (1760) (2), the *Baigneuse* (1758), the superb *Pygmalion and Galatea* (1763) (3) and the *Baiser donné* (4) and *Baiser rendu* (1765) may be mentioned among his most famous works in Sèvres biscuit. The *Pygmalion* is stated by Réau to have been reduced from Falconet's marble by Duru, but is definitely ascribed to Falconet by Lechevallier-Chevignard. A beautiful standing group of *Cupid and Psyche*, adapted from the antique, is also sometimes doubtfully attributed to him (5).

In the period following Falconet's departure for Russia in 1766 it became the established practice to employ sculptors of repute to make reduced versions of their celebrated monumental works. In 1774 Louis-Simon Boizot took charge of the modelling department, and from about the same time hard paste began to be used for the figures, especially the larger ones. Boizot was versatile and accomplished but without genius; typical works of his own in several manners are the famous *girandole* of *Zephyr and Flora*, the coronation group of Louis XVI and Marie Antoinette ('*L'Autel Royale*') and a large *Baigneuse*(6). Boizot's chief assistant was Joseph Le Riche, who became head of the modelling studios from 1780 to 1801; he produced the excellent *Nourrice* in the manner of the earlier Boucher-Falconet groups, as one of a series of '*Moeurs françaises*' after Moreau *le jeune*. Other figures were made by him after designs by Charles-Antoine Coypel, and the paintings and drawings of Oudry and Carle Van Loo were used in the same

(1) *Plate* 70; (2) *Plate* 66; (3) *Plate* 68; (4) *Plate* 67; (5) *Plate* 71; (6) *Plate* 69.

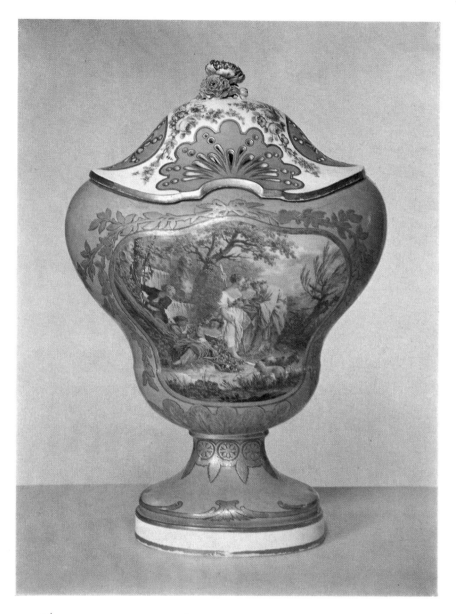

way by other modellers. Amongst the 'outside' sculptors employed to make or reduce models were Jean-Pierre Pigalle (whose *Mercury* was famous), Edmé Bouchardon, Claude-Michel *dit* Clodion, Augustin Pajou (his bust of *Madame du Barry* was reproduced), Jean-Jacques Caffiéri, Jean-Antoine Houdon and Jacques-François-Joseph Saly. Apparently at the instance of d'Angivillier in 1782, busts and statues of famous men were reduced from larger models in bronze and marble. By 1780 the charming pastorals had completely gone out of fashion in favour of mythological subjects and scenes from contemporary literature and the theatre. Classical models were adapted for reliefs on a blue ground, following Wedgwood, and this style culminated in such things as the enormous '*vase Médicis*' of porcelain and bronze with relief decoration, designed by Boizot and Pierre-Philippe Thomire in 1783 and now in the Louvre. The possibility of making very large pieces in hard porcelain facilitated the error of taste.

The simple and graceful forms of vessels in the earlier French tradition survived for some years after the transfer to Sèvres. But many of the characteristic large vases made at the new factory are over-elaborate and lifeless in form, too often simulating metal. The vogue of porcelain, however, was never greater in France than during the last years of Louis XV. It became the custom to use it for diplomatic presents, and many of the 'important' vases in collections outside France were made for this purpose, to serve as centrepieces for rich services such as were sent even to the Chinese Emperor Ch'ien Lung (1764 and 1772). Other diplomatic presents were made to the King of Denmark (1758, 1768), the Elector Palatine (1760), Gustavus III of Sweden (1771), and Tippoo Sahib (1788) (1). A remarkable *garniture* (of which one vase is in the Jones Collection (2)) was decorated to the order of Gastavus III in 1780 and presented by him to the Empress Catherine II of Russia. Perhaps the most famous of all the services was that made for Catherine in 1777–78, which cost over 300,000 livres. The best collections of the more imposing pieces are those in England already mentioned, to which may be added (since 1957) that of Mr. James A. de Rothschild at Waddesdon Manor.

The light 'Vincennes' style of landscape and figure-painting was to some extent maintained at Sèvres, but eventually gave way to a more laborious manner by which the panels were entirely covered with enamel-colour, in the manner of an oil-painting; Vieilliard (3) and Charles-Eloi Asselin, no less than such famous younger men as Etienne-Jean Chabry *fils* (4), Jean-Louis Morin (5) and Charles-Nicolas Dodin (6),

(1) *Plate* 79; (2) *Plate* 78; (3) *Plate* 74B; (4) *Plate* 75; (5) *Plate* 78; (6) *Plate* 76 *and Colour-Plate G.*

practised the new style, which was more logically applied to flat plaques, such as had been used for inlaying in furniture as early as 1759. In monochrome painting, the pink cupids of Dubois (1) and others may be noted. The flower-painting, though soft, delicate and skilful, was decidedly mannered, with little feeling for the beauty of individual flowers: Antoine-Toussaint Cornaille (2), Guillaume Noel (3), Catrice, Vincent Taillandiez, Jean-Baptiste Tandart, Charles Buteux *aîné* (4), Denis Levé *père*, Louis-Jean Thevenet and Pierre-Antoine Méreau *aîné* have been named as the chief flower-painters in the mature Sèvres manner. In the *Louis Seize* designs the flowers lost what little individuality they had, and became with the husk-pattern and the rest mere material for severely set-out swags and festoons, which were nevertheless very delicately done. The Classical fashion brought the characteristic *grisaille* medallions imitating cameos, set in a striped or diapered ground. The introduction of hard paste produced little change but an increasing dryness. Some belated gilt *singeries* in the style of lacquer on a black or brown ground (5), of about 1780, and decoration of scrolls and grotesques and *putti* (6) after Pompeian frescoes and Raphael's designs should be noted. Marie-Antoinette's cups and saucers and milk-bowls for her *Laiterie de Trianon* (7), painted by Lagrenée *le jeune* may be mentioned as typical of the weak decoration adapted from the Pompeiian in the last period (1788).

Painting in panels reserved on a coloured ground is perhaps the most characteristic of all the Sèvres decorations and the succession of the colours used in this way is therefore of great interest. The early dark *gros bleu* has already been mentioned as a Vincennes colour. Next to appear was the turquoise (*'bleu céleste'*), prepared by Hellot in 1752. The yellow (*'jaune jonquille'*) was produced in the following year, a green in 1756, and in 1757 the pink known as *'rose Pompadour'* (miscalled in England *'rose du Barry'*), attributed to Hellot by Garnier but perhaps invented by the painter Xhrouet, who received a *'gratification'* of 150 livres apparently for it. The contemporary vogue of this last, now famous, colour is believed to have ended with the death of the Marquise de Pompadour in 1764, and was certainly little made after Hellot's death in 1767. Meanwhile the beautiful underglaze *gros bleu* had been superseded before 1760 by the powerful even *bleu-de-roi* enamel. Most of these colours had been used, at least tentatively, at Meissen, but their technical excellence at Sèvres and their unequalled smoothness on the soft glaze have given them a great reputation. But it may be questioned whether the powerful opaque

(1) *Plate* 74A; (2) *Plate* 73B; (3) *Plate* 72B; (4) *Plate* 72A; (5) *Plate* 81A; (6) *Plate* 80B; (7) *Plate* 80A.

and mechanicallly perfect later grounds (such as the *rose Pompadour* and the *bleu-de-roi*) are aesthetically superior to the uneven pulsating earlier colours such as the *gros bleu*. Closely associated with the grounds was the finely wrought gilding, sometimes lightly pencilled, but often laid on thickly and delicately chased, sometimes burnished, but more frequently soft and dull. The turquoise ground, which inclined now to blue, now to green, was often richly gilt, and being sometimes very intense, like the *bleu-de-roi*, needed some kind of diaper to soften its excessive brilliancy. The diapers themselves were interesting Sèvres inventions and on rare occasions supplied the sole decoration of a piece (1). Devices of gold or coloured dots or stars were used quite early; a diaper of rings of gilt dots, with white circles enclosed, became very general on the blue and turquoise grounds and was known as *'oeil de perdrix'*. A pattern of ovals of different sizes connected by network was *'cailloulé'* (pebbled); hard and over-regular scale-pattern was also employed. An irregular pattern of rivers breaking up the ground into islands was *'vermiculé'*; this was sometimes painted in blue on the pink ground with an effect of marbling (2). The same two colours sprayed one over the other spiral-fashion gave a rare and curious effect. *Cabochon* jewels were simulated in painting on the *'rose Pompadour'*, which itself varied in tone from a clear pink to a salmon-colour. The rich and very smooth deep green was combined in a distinctive way with the pink and dark blue in interlacing ribbon patterns (*'à rubans'*). The rare lilac-pink should also be mentioned as related to the rose-pink. A late introduction amongst the diapers was the so-called jewelling, supposed to have been invented by Cotteau about 1780, by which drops of coloured enamel were fused over gold and silver foil. A similar technique had been employed at Saint-Cloud earlier in the century (3). Genuine Sèvres specimens with this decoration are rare; a pair of vases in the British Museum (4) are perhaps the finest of their kind recorded and are noteworthy in bearing the date-letter for 1781, a year before the date usually given for the innovation.

Standing apart from the others are the high-temperature ground-colours invented in the 1770's and later for use on (or in) the hard-paste glaze, which did not take the earlier colours kindly. These included brown, aubergine, black, tortoiseshell (*'fond écaille'*) and dark blue, sometimes marbled. They were frequently painted with gilt or silvered designs, such as *chinoiseries* and the *singeries* mentioned above. Pale blues and yellows, also favoured in the last period, were usually diapered with black or brown 'Pompeian' scroll-work.

(1) *Plate* 73A; (2) *Plate* 72B; (3) *Plate* 17C; (4) *Plate* 77, compare also *Plate* 81B.

In the period from 1793 to the end of the century nothing new of importance was invented. Poorly executed specimens with Revolutionary emblems were, however, included in the productions, and effectively bold painting in purple on an imitation red porphyry ground (1) is noteworthy. It may be mentioned that seven persons were continuously employed for four hours on one day in 1793 in the task of smashing the moulds of all royal busts and figures relating to the former *régime*. The workmen were in miserable poverty.

First in this period (in 1793) and later under Brongniart's direction (about 1800, 1804 and 1813) were sold the great quantities of imperfect and undecorated soft paste which enabled private enamellers (such as R. Robins and T. M. Randall in England working for dealers such as Mortlock, and Soiron in Paris) to flood the market with dangerous forgeries, painted with the most costly sorts of decoration and supplied with more or less appropriate date-marks. But the existence of great numbers of these half forgeries has never affected the eagerness, the uncritical eagerness it may be called, with which the productions of the French royal factory have always been sought, especially in England.

(1) *Plate* 81c.

7

OTHER SOFT PASTES: TOURNAY, ARRAS AND SAINT-AMAND-LES-EAUX

Though Tournay in the second half of the eighteenth century was part of the Austrian Imperial dominions and is now in Belgium, it had many historical and cultural connections with France. Its porcelain was also technically of French derivation, and an account of its manufacture is therefore suitably included here.

The factory was founded in 1751 by F. J. Peterinck, under privilege from the Empress Maria Theresa and with financial help from the municipality. The Chantilly and Vincennes 'arcanist' Robert Dubois is recorded at Tournay as 'director' in 1753 and perhaps communicated the soft-paste porcelain secret to Peterinck. The factory remained in Peterinck's charge until 1796, three years before his death at the age of 80. His son Charles Peterinck-Gérard was proprietor from 1797 to 1799; but in 1800 left to found a new factory in the town, which lasted until 1885, chiefly making earthenware. From the date of his departure the older factory fell into decline. Amélie, François Peterinck's daughter, had married Jean-Maximilien-Joseph de Bettignies in 1783, and in the early part of the nineteenth century Tournay was managed by the latter's family. Henri de Bettignies bought the factory in 1817 or 1818, and he and his sons continued to conduct it until 1850, when it passed into the hands of Boch *frères*. In this period were made at Tournay and at the Bettignies' other factory at Saint-Amand-les-Eaux the forgeries of Sèvres, Chelsea and Worcester porcelain with which many collectors are familiar (see p. 51). In recent years forgeries of old Tournay porcelain itself, very thin in body and marked with a large tower, have been made actually in Tournay.

Tournay recalls the English porcelain of Worcester and Derby in a certain trimness and restraint in its decoration, and English workmen were in fact engaged by Peterinck in 1754 and 1759. On the other hand, Tournay modellers may have played a decisive part in the creation of the 'gold-anchor' style at Chelsea. (Sprimont, native of Liége, was perhaps the link.)

FRENCH PORCELAIN

The wares were at first marked with a tower (from the Tournay arms) in various colours or in gold; later, from about 1760, this mark was used only on the finer kinds of porcelain. The more usual Tournay mark, the crossed swords with crosses in the angles (from the arms of Peterinck), was generally in use from 1756 to 1781 on all classes of wares, and even later on the common blue-and-white. But many fine pieces made in the last twenty years of the century (such as the well-known service with birds after Buffon) were unmarked. As usual, un-explained workmen's and painters' marks also appear: the often-repeated assertion that a 'P' of this sort stands for Peterinck is absurd.

The porcelain was a soft paste, at first greyish, but from about 1755 onwards generally of fine quality, with a pleasant faintly yellowish tone.

Much of the earlier decoration was quite frankly imitation of Meissen and Sèvres, but the forms were in many instances original. The Meissen 'osier' pattern was copied in the moulded borders of plates; but a favourite Tournay form has a distinctive spirally curved ribbing (1) with or without the basketwork, and a fine spiral reeding (2), peculiar to the factory, is also found on plates and dishes. Certain distinctive forms of handle appear in the table-wares: often of Rococo outline, they almost always show a longitudinal groove in the sides. But in general the shapes were simple and restrained, even in the Rococo period.

The early painting included 'German flowers', carefully done but inclined to be pale in colour, and copies of the Meissen blue-and-white design known as the 'onion pattern'; the latter long remained a stock design. The commonest of all Tournay porcelain is in fact in blue-and-white. Another favourite pattern was the 'décor ronda' or 'décor aux cinq bouquets' (3), with sprays in Chinese-Meissen style, one in the middle and four on the rim; the blue painting of this was sometimes outlined in gold. There were many other patterns in the same style; in one the middle is occupied by St. George and the Dragon, and this, like some of the others, was occasionally painted in manganese-purple monochrome.

The decoration in Sèvres style done in the best period owed much to Henri-Joseph Duvivier, chief painter from 1763 to 1771, who is said to have been especially proficient in the 'exotic birds' which at Tournay resemble those of Worcester as much as Sèvres, but are usually on a plain white ground. A warm red-brown colour is notice-able in the painting of rocks and earth in these compositions. Figure-painting in Sèvres or Meissen style, often of very good quality, shows

(1) *Plates* 85A, B; (2) *Plates* 82A, 84C; (3) *Plate* 85A.

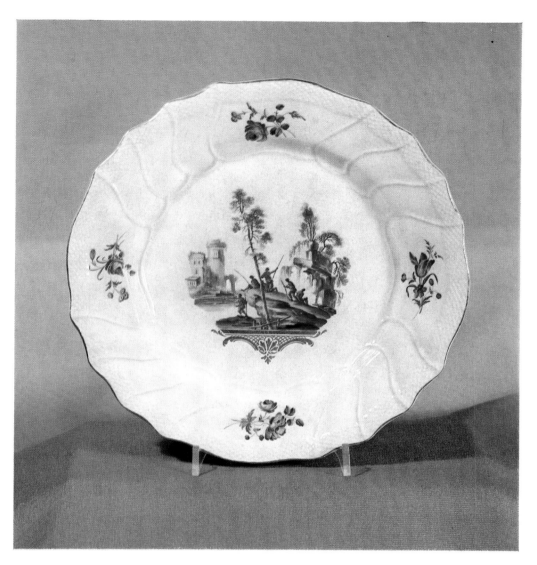

H. TOURNAY. ABOUT 1765. MARK, IN PURPLE ENAMEL, 'I.D.'
(FOR HENRI-JOSEPH DUVIVIER). DIAMETER, $9\frac{1}{8}$ IN.

Victoria and Albert Museum

See page 43

the same colouring. To Duvivier is also attributed the admirable and characteristic painting in crimson monochrome (of noticeably cold tone), somewhat in the Meissen manner, of landscapes with figures, horsemen and castles (1). Cupids, etc., also in this monochrome, were directly derived from Sèvres (2). Some battle-scenes in polychrome (3) in the Meissen manner are recognisable by the characteristic Tournay borders.

Painting in panels on blue and yellow grounds is distinguished by the tone of blue enamel which is rather darker and more violet than the *bleu-de-roi* it imitates, and the yellow, which is paler. The distinctive Tournay gilding on these coloured grounds is of good quality, but inclined to be thick and pasty, and applied in designs that spread over the surface in a freer style than on the comparable Sèvres pieces. '*Oeil de perdrix*' and a 'bamboo-leaf' or quatrefoil diaper were sometimes used on the coloured grounds. It should be remembered, however, that such coloured grounds and gilding were frequently added to old Tournay and other porcelain by forgers (notably the Bettignies) in the nineteenth century.

In the last twenty years of the eighteenth century the *Louis Seize* style was adopted in its less severe form, as at Derby. Certain gilt borders, such as key-fret (4), were much in favour; narrow bands of criss-cross with a slight edge of cresting surround the circular or oval panels or are looped round them ribbonwise (5). Armorial services were often done in this manner. A famous service of this period is that supposed to have been made in rivalry with Sèvres in support of a wager by the Duke of Orleans in 1787; this was painted with birds after the drawings in Buffon's *Natural History* published in the previous year (6). On some similar and typical bowls, 'Pompeiian scrollwork' in gold, 'cameo-heads' in grey monochrome, and birds after Buffon painted in rectangular panels with plain gold outlines, are reserved on a wide band of *bleu-de-roi*—all entirely characteristic of Tournay. These 'Buffon birds' (which were also done on other services and at Sèvres) were painted chiefly by Jean-Ghislain-Joseph Mayer, who had been at Tournay since 1754 and succeeded to the post of head-painter in 1774.

It should be mentioned that much Tournay porcelain was sold 'in the white' for decoration at The Hague, and any soft paste bearing the stork-mark of the latter factory in overglaze blue enamel is likely to be of Tournay manufacture. On the other hand, marked Chantilly porcelain is sometimes found with painting in panels reserved on a coloured,

(1) *Plates* 82A, B, *and Colour-Plate H*; (2) *Plate* 84A; (3) *Plate* 83A; (4) *Plate* 85A, etc.; (5) *Plate* 84B; (6) *Plate* 83B.

usually blue, ground, apparently done at Tournay, but almost certainly Saint-Amand work of nineteenth century date (see p. 51).

The Tournay figures were seldom marked and there is sometimes doubt about their identification. In style they often show a strong resemblance to those of Chelsea, Derby and Mennecy. Most of the models are severally attributed to Nicolas Lecreux, Antoine Gillis and Joseph Willems (who was later on employed at Chelsea); but this is no more than tradition save in the case of those for which the designs by the first-named were preserved until 1898 (they have since been lost; photographs were published by Soil de Moriamé). Nicolas Gauron, employed between 1758 and 1764, was probably a modeller previously at Mennecy and Vincennes and also at Chelsea. A favourite form (perhaps due to Lecreux) was a 'round group' arranged about a tree-stump, with *amorini* or lovers or shepherds or peasants; in one class the figures are twisted into curiously angular postures. The grooved rock bases are distinctive, as are the applied flowers. The *Bird's-nesters* is a characteristic example (1). Some models by Lecreux have a fanciful Rococo trellis background (2) and the figures attributed to him (3) generally show a characteristic miniature delicacy and slenderness which is unique in European porcelain. Amongst the more ambitious pieces are the *Pietà* (of the same model as one in Chelsea) and the allegorical group of Charles d'Oultremont, Prince-Bishop of Liége (1764), both of which are attributed to Gauron. A full list of figures is given by Soil, who has, however, included a few models that are more likely to be of Mennecy or other French origin. Coloured figures were made as well as white-glazed models, which, however, are by far the most numerous. The biscuit groups of playing children are likely to be confused with Derby.

<p style="text-align:center">★ ★ ★</p>

The soft-paste manufactures at Arras and Saint-Amand-les-Eaux in Northern France were obviously affiliated to Tournay and made a similar porcelain material. Arras was founded in 1770 by J. F. Boussemaert of Lille, taken over in the following year by four ladies, the Dlles Delemer, and came to an end in 1790. Saint-Amand porcelain was made by J. B. J. Fauquez from 1771 to 1778, and again in 1818 (or earlier) onwards by Maximilien-Joseph de Bettignies of Tournay.

The porcelain made at both these factories was of the simpler Tournay (4) and late Chantilly types. The activities of the Bettignies family in the nineteenth century in making forgeries and redecorating old Sèvres, Tournay, Chantilly, Arras and other soft pastes, are mentioned on other pages (pp. 17, 41 and 51).

(1) *Plate* 87; (2) *Plate* 86B; (3) *Plate* 86A; (4) *Plate* 85C.

STRASBURG AND OTHER FACT-
ORIES IN THE EAST OF FRANCE

Strasburg in Alsace differs from all other French factories in having derived its porcelain technique and styles direct from Germany. The hard-paste porcelain made by Paul Hannong at Strasburg in 1752–53 was due to the famous German 'arcanist' J. J. Ringler, and bore the same mark as the earliest ware made by Hannong at Frankenthal in the Palatinate after his expulsion from France in 1755. It is only with difficulty distinguished from the earliest Frankenthal, to an account of which the reader is referred.

When in 1762 Paul Hannong's son Joseph-Adam Hannong sold the Frankenthal factory to the Elector Palatine and returned to France, he quickly found himself in difficulties with the French authorities, who having expelled his father on the ground that Strasburg was part of France, now proposed to regard it for customs purposes as '*étranger effectif*'. Attempting to resume the manufacture of porcelain at Strasburg about 1768 he soon ran into debt, meeting also with technical difficulties over the *kaolin* of Limoges, which he was compelled to use instead of the Passau clay he had relied upon at Frankenthal.

His stock of models differed widely from those of the older Strasburg in the Rococo style, the moulds for which had apparently been left behind at Frankenthal. The influence of the *Louis Seize* style was now unmistakable; a tureen with straight fluted legs is characteristic (1). Other table-wares show a distinctive style of painting figures in landscapes (2). Some of the figure-models were copied from other factories —the Vincennes *Babet with a bird-cage* and the *Little Stonemason* were among these—but the *Fisher-boy and Girl*, the pair of *Quarrelling Boys* (3) (examples at the Victoria and Albert Museum and at Strasburg), some groups of playing children (4), a charming *Faun* (at Hamburg and Sèvres), and the *Dwarfs* at the Sèvres Museum are finely modelled and apparently original works by an unidentified artist, possibly Valentin Gusi; in colour, however, they are much less attractive, with dull paint-like pigments smeared over them. The factory was

(1) *Plate* 93B; (2) *Plate* 93A; (3) *Plate* 92A; (4) *Plate* 92B.

closed in 1781 after Joseph Hannong had fled to Germany to escape imprisonment for debt.

The Niderviller factory in Lorraine owed its staff and technique of porcelain manufacture to Strasburg. It was founded in 1754 by Baron Jean-Louis de Beyerlé, and added porcelain to its productions in 1765, but in small quantity at first, on account of the interference of Sèvres. The factory was sold in 1770–71 to Adam Philibert, Comte de Custine, with whom was associated as manager or partner Claude-François Lanfrey, who took over the concern on his own account when Custine died on the scaffold in 1793, and after an interval during which it was closed conducted it until his death in 1827.

The best Niderviller productions were in the Rococo style, which was going out of fashion when the porcelain began to be made. Some attractive pieces in an intermediate style bear the mark of Beyerlé (1), while some tureens (2) and dishes in scrolled and naturalistic forms are almost the only representatives in French porcelain of a typical eastern French manner. For the rest, the Niderviller table-wares in porcelain are for the most part indistinguishable from the contemporary wares of the Paris factories with sprig patterns, of cornflowers, etc. Some table-wares, however, bear landscapes in an individual style (3).

The Niderviller figures achieved an individual style. Those in faïence were largely the work of Paul-Louis Cyfflé of Lunéville, who sold his stock of moulds to Niderviller in 1780. The sculptor Charles-Gabriel Sauvage, known as Lemire, was probably employed as early as 1759, when 'Charles Mire garçon-sculpteur' appears in a list of hands, and it is likely that some of the porcelain figures, of popular types, somewhat in Cyfflé's style and probably inspired by him, dating from the 1760's and 1770's, may be Lemire's work. But his fame is due rather to his naked figures and Classical pieces. A famous work of this kind is the allegorical group now in the Museum at Colmar, made in 1770 for the occasion of Marie-Antoinette's stay in the Castle of Strasburg on her way to Paris for her marriage to the Dauphin, afterwards Louis XVI; it is inscribed 'CARA DEUM SOBOLES', and bears a paper label on which is written 'Lemire sculpteur à la fabrique de Niederviller'. Lemire remained at the factory until about 1806, and the price-list gives his name to a large number of models.

The Niderviller porcelain figures are often in biscuit of a pure but cold white colour, with a sugar-like translucency and at times a slight gloss. The smaller and better models have the good qualities of those in faïence (4). Others, in the Classical style, are often very large. A good example is a *Shepherd Boy* in the Victoria and Albert

(1) *Plate* 88A; (2) *Plate* 88B; (3) *Plate* 89; (4) *Plates* 91A, B.

Museum (1), which is 24 inches high; a *Bathing Shepherdess*, is 25 inches. A *Bacchante* in the same Museum (17 inches high), and its companion bear the incised signature on the edge of the base, 'LE MIRE PERE'. An important large coloured porcelain group of the Virgin and Child attributed to Lemire in the Sèvres Museum is inscribed in black, 'DONNE A L'EGLISE DE LA S^{te} CROIX A NIDERVILLER PAR M. F. LAN-FREY ET COMP. LE 8^{me} 7^{bre} 1784'. Though finely modelled, it is enamelled in unpleasant paint-like colours. It has a scrolled base, in contrast to the usual flat circular plinths.

The Lunéville porcelain made by Paul-Louis Cyfflé at a factory of his own, founded in 1766, is a fine-grained warm-toned true porcelain and was doubtless the material referred to in an order issued from Sèvres in 1769, authorising the continuance of Cyfflé's manufacture of the previously forbidden porcelain, on condition that the wares were sold as 'terre cuite'. In Cyfflé's appeal this porcelain was termed 'pâte de marbre', and the mark 'TERRE DE LORRAINE' (or 'T D L'), probably dates from this time. (It appears also on the 'terre de pipe', a softer material made at Chambrette's factory at Lunéville). Cyfflé left Lorraine about 1777, considerably embarrassed financially, and his factory and stock were sold in 1780, most of the moulds passing to Niderviller, and some probably to Bellevue.

Cyfflé's own modelled work is characterised by a certain homely sentiment. The well-known *Cobbler*, whistling to his caged starling, and the companion *Stocking-mender*, the girl with a broken flower-pot, the popular group of young lovers ('*Le Baiser*'), *Belisarius and his daughter*, the little boy *Sweep*, the children with a dead bird (2), and the busts of Henri IV and Voltaire are characteristic examples in several styles. Of Lunéville models of other types should be particularly mentioned a large biscuit figure of King Stanislas, in the Sèvres Museum, inscribed '*Cyfflé* 1766', probably one of the earliest productions of his own factory, and a beautifully made version of Saly's *Faun* in porcelain, of which an example in the British Museum is marked 'T D L' impressed and '*Jacque*' incised.

(1) *Plate* 90; (2) *Plate* 91C.

PARIS AND MISCELLANEOUS FAC-
TORIES MAKING HARD PASTE

Though Saint-Cloud had a branch in the rue de la Ville l'Evêque and the Villeroy manufacture started in the rue de Charonne it is customary to limit the meaning of the term 'Paris porcelain' to cover only the productions of the numerous factories making hard-paste from about 1770 onwards. That started at Vincennes in 1765 by Pierre-Antoine Hannong, son of Paul Hannong of Strasburg and Frankenthal, might well be included. The same 'arcanist' founded the factory in the Faubourg Saint-Denis (1) (or Faubourg Saint-Lazare) in 1771. That of Locré and Russinger at La Courtille (rue Fontaine-au-roy) began in the same year and enjoyed no royal patronage, but was very productive. Clignancourt (1771) (2), the rue Thiroux (1775) (3) and the rue de Bondy (1780) (4) were protected by members of the royal family. These three and that of the comte d'Artois (Faubourg Saint-Denis, 1771, as above) were the factories at last authorised to make porcelain by the Sèvres order of 1787. The factories of Nast (rue Popincourt), of Darte (at various addresses), and of Honoré and Dagoty (Petite rue Saint-Gilles, etc.) flourished chiefly in the *Empire* and subsequent periods. Particulars of these and of the hard-paste manufactures elsewhere in France not hitherto mentioned will be found with their marks on pages 58 to 69.

It should be noted that all the rival factories were founded subsequently to the discovery of the *kaolin* of Saint-Yrieix (Limoges), with the exception of that of Brancas-Lauraguais (see p. 58), who used the *kaolin* of Alençon, and those of Vincennes (Hannong's factory), of Vaux, of Etiolles (5) and of eastern France, where the 'arcanists' had knowledge of German sources.

The hard-paste material and the styles of decoration employed on this later French porcelain were without any strong individuality, and unmarked pieces are commonly difficult to assign to particular factories. The mannered but often delicately painted *Louis Seize* de-

(1) *Plate* 94c; (2) *Plate* 96; (3) *Plate* 95c; (4) *Plate* 95A; (5) *Plate* 94A.

signs were succeeded by the pompous *Empire* styles, all largely imitated from Sèvres. Specimens from the four quasi-Royal factories are often equal to the Sèvres productions in hard-paste, and these, with the best work of La Courtille, are the only Paris porcelains really worthy of the collector's attention.

10

FORGERIES

French porcelain has for long attracted the attentions of the forger. A well-known Paris manufacturer has copied all the soft pastes, making no difficulty over the tin-glaze of Chantilly but naturally failing to reproduce the pellucid whiteness of Mennecy, Vincennes and Sèvres. These copies sometimes bear the maker's mark of two 'S'S' in monogram, but are more often supplied with the mark of the original copied. Nineteenth-century versions of old Sèvres biscuit fail chiefly in coarser quality of the paste. Early forgeries of Sèvres are apt to bear impossible date-letters; the meaning of the marks was at the time not understood. Apart from such tell-tale features these forgeries may be recognised chiefly by a failure in the drawing.

In England, Minton's made honest copies of Sèvres, but those made at Coalport often bear Sèvres marks; a Coalport specimen in the Jones Collection (now Victoria and Albert Museum), bought as Sèvres, was once questioned, and the dealer's apocryphal enquiry of the Sèvres factory produced an apocryphal assurance of genuineness, with 'particulars' alleged to have been found in the 'records'. T. M. Randall at Madeley, also in Shropshire (about 1825–40), made a soft paste resembling Sèvres which was provided with turquoise and other coloured grounds and painting in eighteenth-century styles.

All the above are wholly false. More dangerous are the half-forgeries of Sèvres made of genuine old soft-paste porcelain sold 'in the white' from the factory in 1793 and later, and decorated in London and Paris in the most costly eighteenth-century styles (see pp. 2, 30, 39). Black specks and discolouration due to inexperienced firing or to an accumulation of dirt and grease on the surface of the old porcelain, accuse many of them. Many of the old Sèvres plates and dishes sold 'in the white', being 'seconds', showed some defect, such as warping, by which the forgery is accused. The marks on these again are often impossible for the type imitated. 'Important' subjects (such as Kings and Queens) are always wrong, never having been done in the eighteenth century. *Rose Pompadour* and turquoise grounds, 'jewelled' decoration and the marks of famous or interesting painters, such as Vieilhard, Morin, Dodin and Vincent ('2000'), are danger signals. But where the soft paste is genuinely old and the painting unpretentious it is often

difficult to decide. It was reported half a century ago that Georges Lechevallier-Chevignard, director and historian of the Sèvres factory, confessed his inability to distinguish false from genuine in the case of a number of doubtful specimens submitted to him from the collections of the Victoria and Albert Museum.

Another numerous class of half-forgeries originated apparently at Saint-Amand-les-Eaux, where the manufacturer Bettignies was seen by Lady Charlotte Schreiber making forgeries of old Sèvres, Tournay, etc., in 1877. Plates and dishes of Sèvres, late Chantilly, Arras and Tournay porcelain, with slight decoration of sprigs, etc., in underglaze blue, are found with *gros bleu*, yellow and other ground-colours hiding the sprigs, and reserved panels outlined with rich gilding of good quality, often of palm branches and birds. The Sèvres 'jewelled' decoration was also imitated, unsuccessfully. Unmarked originals usually have Sèvres marks provided. Others, like a Chantilly plate with an added yellow ground in the Franks Collection at the British Museum, retain their original marks, and only arouse suspicion when it is remembered that wholly genuine Arras porcelain (for example) does not bear such rich polychrome painting and gilding. It is said that similar added decoration has sometimes been applied to old French soft paste which has been stripped of its original decoration with acid or by grinding.

In general it may be said that forgeries may often be detected by their use of wrong enamel colours, such as the nineteenth-century yellowish chrome green instead of the emerald copper green; but many specimens pass all such tests only to be accused by weak and insignificant brushwork. In the worst cases, such as would deceive none but the novice, the 'painting' has been done by means of a modern chromolithographic transfer, which has an even shiny surface.

11

MARKS

The factories are given here in approximately chronological order of foundation, beginning with the early soft pastes, and with the exception of the Paris factories, which are placed together at the end of the hard pastes.

While many marks on French porcelain may be safely interpreted, there still remain so many obscurities as to make them an untrustworthy guide to identification by factories.

ROUEN

No factory-mark is certainly attributable to Rouen. The 'A P' mark given to Saint-Cloud below has sometimes been unconvincingly ascribed to Rouen. See also page 6

SAINT-CLOUD
(see also page 8)

In blue (1)	In blue (2)	Incised (3)	In blue (4)	In blue (5)

(1) Late seventeenth century to about 1722.

(2) and (3) About 1722–66.

(4) Mark erroneously attributed to Rouen; probably Saint-Cloud.

(5) Mark of crossed arrows doubtfully attributed to François Hébert of the rue de la Roquette, Paris, who married a member of the Chicaneau family; probably Saint-Cloud.

Various unexplained initials occur on Saint-Cloud porcelain, and of these the 'L' and the 'D' have been erroneously attributed to an early soft-paste-factory at Lille (see below, page 56), and 'MP' to Etiolles (see page 61). 'CM' over a cross has been doubtfully attributed to Moreau (Marie) and Chicaneau (L.-D.-F), 1722–31.

CHANTILLY
(see also page 15)

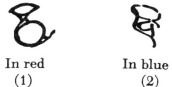

In red	In blue
(1)	(2)

(1) Early mark, 1725 to about 1760 or later. The mark is written in gold only (it seems) on pieces painted with the 'red-dragon' pattern (examples in the Victoria and Albert Museum, *Plate* 22, and Paris Exhibition of 1929, No. 235).

(2) Late mark, about 1760 onwards.

The hunting-horn incised or in relief is also recorded (see p. 14); and the word 'Chantilly' in full, in blue, in addition to the horn, appears (rarely) on late blue-and-white painted with sprigs, as in *Plate* 33A.

MENNECY, SCEAUX, BOURG-LA-REINE AND CRÉPY-EN-VALOIS
(see also page 19)

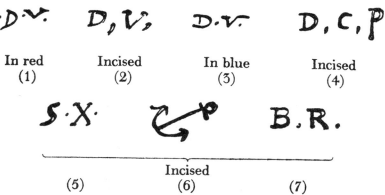

In red	Incised	In blue	Incised
(1)	(2)	(3)	(4)

(5)	Incised (6)	(7)

(1) Early mark, about 1735.

(2) Usual mark, about 1740–70.

(3) Early mark on blue-and-white, about 1735.

(4) On pieces in Mennecy style, perhaps Crépy-en-Valois, about 1762–65 (see page 23); 'D, C, O' also occurs and may indicate some connection with Orleans, where Mennecy hands were employed (see page 24) and the Mennecy style adopted.

(5) and (6) On Sceaux porcelain, about 1763–72. The anchor signifies the protection of the Duc de Penthièvre, *grand amiral*.

(7) On Bourg-la-Reine, 1773 to about 1780.

A forged 'D V' mark has been incised after making on a vase in the Victoria and Albert Museum, of Bow porcelain, which sometimes resembles Mennecy.

VINCENNES AND SÈVRES
(see also page 25)

FACTORY-MARKS

(1) *Reigns of Louis XV and Louis XVI (about 1745 to 1793).*

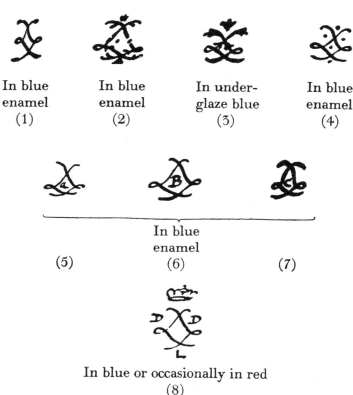

In blue enamel (1)	In blue enamel (2)	In under- glaze blue (3)	In blue enamel (4)

In blue enamel

(5) (6) (7)

In blue or occasionally in red
(8)

Nos. (1) to (4) are specimens of the marks in use before 1753. It has been declared, without proof, that marks without a dot between the 'L's' are earlier than those with one or more dots, dating back to 1738. It seems probable, however, that the mark itself was not in use before 1745, perhaps not much before 1750.

Nos. (5) to (8) are specimens of the marks with date-letters, to which a key is given below. Occasionally (as in No. 8) the letters were written by the side of the crossed 'L's' and not enclosed.

No. (8), the mark with a crown, was used on hard paste from 1769–72 to 1793 (see page 29); occasionally also found on soft paste.

A decorator named Feuillet about 1820–1850, working in Paris, rue de la Paix, used a mark of crossed 'L's' in gold enclosing 'F', as well as his name in full, on hard-paste porcelain.

A indicates 1753			V indicates 1774		
B	,,	1754	X	,,	1775
C	,,	1755	Y	,,	1776
D	,,	1756	Z	,,	1777
E	,,	1757	AA	,,	1778
F	,,	1758	BB	,,	1779
G	,,	1759	CC	,,	1780
H	,,	1760	DD	,,	1781
I	,,	1761	EE	,,	1782
J	,,	1762	FF	,,	1783
K	,,	1763	GG	,,	1784
L	,,	1764	HH	,,	1785
M	,,	1765	II	,,	1786
N	,,	1766	JJ	,,	1787
O	,,	1767	KK	,,	1788
P	,,	1768	LL	,,	1789
Q	,,	1769	MM	,,	1790
R	,,	1770	NN	,,	1791
S	,,	1771	OO	,,	1792
T	,,	1772	PP	,,	1793
U	,,	1773	(until 17th July)		

(2) *First Republic* (1793 to 1804) *and First Empire* (1805 to 1815).

In blue	In blue	Printed in red
(1)	(2)	(3)

Nos. (1) and (2) give no indication of year. The word '*Sèvres*' alone was used in gold or colour, it is said, between 1800 and 1802.

No. (3) is said to be the mark of the Consular Period (1803–04), but the sign included in it seems to be that for the year XIII (1805), as given in the table below.

From 1801, the indications of date were resumed and the following signs were used:

T 9	indicates	IX (1801)		9	indicates	1809
X	,,	X (1802)		10	,,	1810
11	,,	XI (1803)		oz	,,	1811
÷	,,	XII (1804)		dz	,,	1812
╫	,,	XIII (1805)		tz	,,	1813
ʊ	,,	XIV (1806)		qz	,,	1814
7	,,	1807		qn	,,	1815
8	,,	1808		sz	,,	1816

The painter's marks added to the factory- and date-marks on Vincennes and Sèvres porcelain are reproduced, with many discrepancies, in the books by Chavagnac and Grollier and by Lechevallier-Chevignard, and in many mark-books. They will be re-examined and reproduced in a later book in this series, devoted to Vincennes and Sèvres alone.

Many discrepancies occur also between the published tables and the marks on the actual wares, which are apt to take irregular forms.

LILLE

A soft-paste manufacture supposed to have been started in 1711 by Barthélémy Dorez and Pierre Pélissier and continued until 1730; 'L' and 'D' on pieces of Saint-Cloud type have been erroneously declared to be Lille marks.

In blue
Of doubtful significance, supposed to be the mark of F. and B. Dorez, but also claimed for J.-F. Boussemaert, for whose Arras (1770) porcelain the Saint-Cloud style of the pieces that bear it is too early.

For Lille hard paste, see page 63.

TOURNAY

Soft-paste manufacture started by Peterinck in 1751: see page 42.

In blue (1)	In gold (2)	In blue or gold (3)	In purple enamel (4)

(1) and (2) Early marks, 1751 to 1760; later, on finer wares only.

(3) Later mark, about 1756–80 and perhaps later, on all classes of ware. (4) Mark of (Henri-) Joseph Duvivier, used in conjunction with (3) in gold (Colour Plate H).

ORLEANS

Manufacture started in 1753, for the making of '*terre blanche purifiée*', perhaps soft-paste: see also page 24.

Mark registered in 1766. A small version of this mark occurs on a covered jug, painted with flowers in Mennecy style, in the Sèvres Museum.

The mark of an heraldic label, certainly used on hard-paste made at Séguin's Vincennes factory (see page 59), is on soft-paste commonly ascribed to Orleans, but is there more likely to be a Chantilly mark on services made for Louis-Philippe, Duke of Orleans (1752–85): compare page 17.

ARRAS

(see also page 44)

Soft-paste manufacture. Started in 1770 by Joseph-François Bousse-maert and continued by the Dlles Delemer until 1790.

AR

In blue, crimson or purple.

SAINT-AMAND-LES-EAUX
(see also page 44)

A manufacture of soft paste was conducted here between 1771 and 1778 by Jean-Baptiste-Joseph Fauquez; it was resumed in 1818 or earlier by Maximilien-Joseph de Bettignies.

In blue

BRANCAS-LAURAGUAIS

A private factory was conducted at the Château de Lessay by Louis-Léon-Félicité, Duc de Brancas, Comte de Lauraguais. Hard paste was made experimentally with the *kaolin* of Alençon, perhaps as early as 1752; medallion portrait reliefs, marked as below and bearing dates between 1764 and 1768, are the only reasonably well authenticated specimens. Most of them are in the Sèvres Museum.

Incised
(much reduced)

VINCENNES
(see also page 48)

Hard-paste manufacture started by Pierre-Antoine Hannong in partnership with Maurice des Aubiez (1765–1768).

H·L·	L·H·	𝆑
In blue	In blue	In blue
(1)	(2)	(3)

(1) and (2) For Hannong and La Borde (about 1769–70); or possibly Hocquart and La Borde of VAUX (Seine-et-Oise, near Paris), where La Borde, *Valet de Chambre* to Louis XV, ran a porcelain-factory concurrently with that of Vincennes for a short time from about 1769. See also Bordeaux (page 62) for a mark of crossed 'V's' supposed to be

58

a mark of Vaux. In 1769 La Borde offered his porcelain to the Sèvres factory, then seeking to manufacture hard paste.

(3) For Louis-Philippe, duc de Chartres, mark registered by Séguin (1777–88); for heraldic-label-marks on soft paste, compare Orleans, page 57.

STRASBURG
(see also page 45)

Hard paste was made between about 1752 and 1755, and about 1768 and 1781.

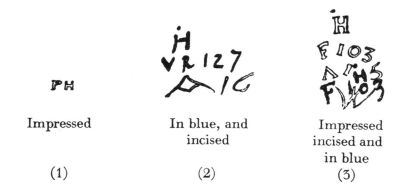

PH		
Impressed	In blue, and incised	Impressed incised and in blue
(1)	(2)	(3)

(1) For Paul Hannong (about 1752–55).

(2) and (3) Marks of Joseph-Adam Hannong (about 1768–81). Many other similar subsidiary marks occur; the monogram 'I H' in blue (2) is found on table-wares, that impressed (3), on figures.

LUNÉVILLE
(see also page 47)

Hard-paste biscuit was made by Paul-Louis Cyfflé from 1766 to 1777.

Impressed

NIDERVILLER
(see also page 46)

Hard paste was made from about 1765 onwards.

In enamel colours

(1) (2) (3) (4)

Impressed
in relief on
an applied
label

stencilled

(5) (6)

(1) and (2) Marks of Beyerlé (1754–70; porcelain was made from about 1765 onwards).

(3) and (4) Marks of Custine (1770–93). In the Custine period a script 'N' in enamel colour was also used on table-wares. The coronet in No. 4 is often omitted. The Ludwigsburg mark is similar but usually in underglaze blue.

(5) Mark on biscuit, about 1775–85.

(6) Mark of Lanfrey (1793–1827).

ETIOLLES
(near Paris, Dept. of Seine-et-Oise)

Hard-paste manufacture started in or before 1768 by J. B. Monier and Dominique Pellevé, previously of Ottweiler. Its duration beyond 1770 is unknown. The productions are of Paris type (*Plate* 94A).

Incised (reduced) Incised Incised
(1) (2) (3)

60

(2) occurs on a cup belonging to a saucer bearing (1).

(3) Registered in 1768; occurs also in blue on soft paste of Saint-Cloud type, on pieces ascribed to Etiolles apparently in error.

MARSEILLES

Hard paste was made in small quantity about 1775, it is said, from the *kaolin* of Alençon; the decoration resembles that of the well-known Marseilles faïence.

Marks of Joseph Robert

LIMOGES

Hard-paste manufacture started in the faïence-factory of Massié in 1771 by the brothers Grellet and Fournier under the protection of the Comte d'Artois; in 1784 the factory of Grellet and Massié was acquired by the King to make hard paste for decoration at Sèvres. The *kaolin*-quarry-owner Alluaud was director in 1788–93. Came to an end in 1796. See also page 30.

Incised or in colour	Incised and in blue enamel
(1)	(2)

(1) For the Comte d'Artois.

(2) Factory mark incised, with Sèvres mark and painter's mark added in blue enamel. The mark '*Porcelaine de Limoges*' and similar inscriptions, in red, are sometimes found in addition to the factory-mark.

Another factory was founded in Limoges by Etienne Baignol (1797–1821), and continued by his son and successors until 1854.

SAINT YRIEIX ('LA SEYNIE')
(near Limoges)

Hard paste was made intermittently, at a factory started by three noblemen, including the Marquis de La Seynie, from 1774. In 1789 it

was conducted by Etienne Baignol, who gave it up in 1794; after a period of disorder it was acquired by Honoré of Paris, who passed it on about 1822 to Dominique Denuelle. It lasted until the middle of the nineteenth century.

£ *LS*

In red

TOURS

Hard-paste manufacture founded by Thomas Sailly, 1776–83. Rare marked specimens bear the name 'Tours' incised.

BOISSETTE
near Melun (Seine-et-Marne)

Hard-paste manufacture started in 1778 by Jacques Vermonet and his son, apparently under the protection of the Duke of Orleans, and an heraldic label-mark (compare pages 57 and 58) has been erroneously ascribed to it. A biscuit group bears the incised inscription: '*Manufacture de S. A. S. Mgr le Duc d'Orleans, A. Boisset*'. Duration unknown.

B..

In blue
about 1780

BORDEAUX

Hard-paste was made by Pierre Verneuilh and his nephew Jean from 1781 to 1787, and by Michel Vanier and Alluaud from 1787 until 1790 (*Plate* 94 B).

In gold Stencilled
in red

(1) (2)

(1) 'V V' (Verneuilh and nephew), 1781–87. Other similar marks have been regarded as a monogram and mark of Vaux (see page 58).

(2) For Vanier and Alluaud (1787–90).

LILLE

Hard-paste manufacture started in 1784 by Leperre-Durot under the protection of the Dauphin.

Stencilled in red
(a dolphin for the Dauphin)
(1784 to about 1790)
For Lille soft paste, see page 56.

VALENCIENNES

Hard-paste manufacture started in 1785 by J.-B.-J. Fauquez.

In blue
Monogram of Fauquez, Lamoninary and
Vanier (or Valenciennes); about 1785–86

VALOGNES (BAYEUX)

Hard-paste manufacture started in 1793 at Valognes; transferred in 1810 to Bayeux.

VL
Bayeux

1810–47

FONTAINEBLEAU

Hard-paste manufacture started in 1795; bought in 1830 by Jacob and Mardochée Petit under whom it became very prosperous, making crude and showy wares.

J.P.

In blue (or incised)
Mark of Jacob Petit, about 1830 and later

CAEN

Hard-paste manufacture managed in turn by d'Aigmont-Desmares and Ducheval.

caen

About 1793 to 1806

PARIS, FAUBOURG SAINT-DENIS
(otherwise Faubourg Saint-Lazare)

Hard-paste manufacture, started in 1771 by Pierre-Antoine Hannong; taken over in 1776 by the Marquis d'Usson under the protection, from 1779, of Charles-Philippe, Comte d'Artois (*Plate* 94c); see also page 48.

✗	CP	*Schoelcher*
In blue	Stencilled in red	In red or other colour
(1)	(2)	(3)

(1) Hannong's mark, 1771–76.
(2) For Charles-Philippe, Comte d'Artois, 1779–93.
(3) Early nineteenth century.
Another factory, conducted by Fleury and Flamen Fleury, was in the Faubourg Saint-Denis (1803–35).

PARIS, LA COURTILLE (RUE FONTAINE-AU-ROI)

A flourishing factory started in 1771 by Locré and managed by Laurentius Russinger. About 1795 Locré withdrew and in 1800 Pouyat of Limoges joined the firm, which continued to exist until 1841. See also page 48.

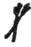

In blue

Crossed torches, often written to resemble the crossed swords of Meissen; also incised on biscuit.

PARIS, CLIGNANCOURT

Started in 1771 by Deruelle, succeeded by Moitte, in existence till 1798; from 1775 until 1791 under the protection of Louis-Stanislas-Xavier, Comte de Provence, otherwise Monsieur, brother of Louis XVI.

In blue	Stencilled in red	In blue or red
(1)	(2)	(3)

(1) Registered mark of a windmill, about 1775; probably used from 1771 onwards.

(2) Monogram of the initials of Monsieur, 1775–91; also registered in 1775.

(3) For Moitte, late eighteenth century.

PARIS, GROS CAILLOU

Registered by Advenir and Lamarre in 1773, continued till 1784 or later.

In blue
mark registered in 1773

PARIS, RUE DU PETIT CARROUSEL

A decorating-establishment conducted by Charles-Barthélémy Guy and his son Charles, 1774 to 1800. A decorator named Perche was employed, whose name sometimes appears in the mark.

Stencilled in red

PARIS, RUE DE REUILLY

Registered in 1774 by Jean-Joseph Lassia.

L

In colour or gold
about 1774–84

PARIS, RUE DE LA ROQUETTE

Started in 1774 by Vincent Dubois. Another factory started by Souroux in the rue de la Roquette registered in 1773 the mark of the initial of the proprietor, 'S'.

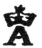

In blue or incised on biscuit pieces

Compare also Saint-Cloud, Mark No. 5.

PARIS, RUE THIROUX

Started in 1775 or earlier by Leboeuf, under the protection of Queen Marie-Antoinette; the productions were known as '*Porcelaine de la Reine*'; see also page 48.

In blue	In red
(1)	(2)

(1) For Queen Marie-Antoinette, about 1775–93.
(2) For Guy and Housel, proprietors in 1797–98.

PARIS, PONT-AUX-CHOUX

Mark registered by Mignon in 1777 but productions rarely found.

In blue
Also ascribed to Savy of Marseilles

PARIS, BARRIÈRE DE REUILLY

Conducted by Henri-Florentin Chanou, 1779–85.

CH

In red
Mark attributed to Chanou

PARIS, RUE DE BONDY

Started in 1780 by Dihl, who took Guerhard as a partner not later than 1786. Protected by the Duc d'Angoulême. Moved to rue du Temple in 1795 and to Boulevard Saint-Martin in 1825. The so-called 'Angoulême sprig', of formal cornflowers in green, blue and pink, supposed to have been a favourite decoration of Marie-Antoinette, and copied at many factories, takes its name from this one. See also page 48.

	MANUFRE de Mⁿⁱ le Duc d'Angouleme	MANUFRE de MM Guerhard et Dihl a Paris
In blue	Stencilled in red	Stencilled in red
(1)	(2)	(3)

(1) Mark registered in 1781 for 'Angoulême'; occurs also stencilled in red below the words 'Rue de Bondy'.
(2) About 1780 to 1793.
(3) About 1793 to 1829 (?).

PARIS, RUE POPINCOURT

Founded by Nast in 1782; continued until 1835; latterly very prosperous.

NAST à PARIS

Stencilled in red
Early nineteenth century

67

PARIS, RUE AMELOT

Registered in 1784 by La Marre de Villiers in partnership with Montmarcy. Protected from 1786 by Louis-Philippe, Duke of Orleans.

Stencilled in red	Stencilled in red	In blue
(1)	(2)	(3)

(1) Presumed to have been registered (1784–86).

(2) Mark of Montarcy and Outrequin, 1786.

(3) Mark indicating protection of Louis-Philippe, Duke of Orleans, 1786–93. The same mark, on a *soft-paste* specimen in the Grollier Collection in the Sèvres Museum, is thought to refer to an earlier Duke of Orleans ('le Devot', b. 1703, d. 1752), who made porcelain researches at Bagnolet about 1751; a letter of this date refers to the Duke's success in making such a specimen.

PARIS, PETITE RUE SAINT-GILLES

Founded in 1785 by François-Maurice Honoré, who early in the nineteenth century, until about 1822 was associated with Dagoty, owner of a factory in the Boulevard Poissonnière. The numerous productions marked with the proprietors' names chiefly date from the early part of the nineteenth century.

PARIS, RUE DE CRUSSOL

Started in 1789 by an Englishman, Christopher Potter ('*Manufacture du Prince de Galles*'). Transferred about 1792 to E. Blancheron (*Plate* 95B).

Potter
Paris
86

EB

In blue	In blue
(1)	(2)

(1) About 1790. (2) About 1795.

PARIS, RUE DE CHARONNE (about 1795), RUE DE LA ROQUETTE, PALAIS ROYAL, RUE POPINCOURT, RUE FONTAINE-AU-ROI

Factories and decorating-shops owned by Darte, 1795 to 1840.

DARTE
Pal.Royal
N° 51

Stencilled in red
Early nineteenth century

12

A SHORT BIBLIOGRAPHY

L. Courajod (ed.), *Livre-Journal de Lazare Duvaux, Marchand-Bijoutier Ordinaire du Roy*, 1748–58. Paris, 1873.

G. Vogt, *La porcelaine*. Paris, 1893.

A. Milet, *Historique de la faïence et de la porcelaine de Rouen, au XVIIᵉ siècle*. Rouen, 1898.

A. Darblay, *Villeroy, son passé, sa fabrique de porcelaine, son état actuel*. Paris, 1901.

G. Macon, 'Les arts dans la Maison de Condé', in *Révue de l'art ancien et moderne*, XI (1902), p. 202.

E. S. Auscher, *A History and Description of French Porcelain*. London, 1905.

*X. de Chavagnac and A. de Grollier, *Histoire des manufactures françaises de porcelaine*. Paris, 1906.

Sale Catalogue (Paris, 20th–22nd February, 1907), *Comte d'Yanville Collection*.

G. F. Laking, *The Sèvres Porcelain of Buckingham Palace and Windsor Castle*. London, 1907.

*G. Lechevallier-Chevignard, *La manufacture de porcelaine de Sèvres*. Paris, 1908.

E. Bourgeois, *La Biscuit de Sèvres au XVIIIᵉ siècle*. Paris, 1909.

Sale Catalogue (Paris, 13th–16th December, 1909), *J. H. Fitzhenry Collection*.

[X. de Chavagnac], *Catalogue des porcelaines françaises de M. J. Pierpont Morgan*. Paris, 1910.

R. Peyre, *La céramique française*. Paris, 1910.

Sale Catalogue (Paris, 19th–21st June, 1911), *X. de Chavagnac Collection*.

G. Arnaud d'Agnel, *La faïence et la porcelaine de Marseille*. Paris and Marseilles, 1912.

*G. Bapst, Sale Catalogue (Paris, 22nd-23rd May, 1913), *Frédéric Halinbourg Collection (Chantilly)*.

E. Bourgeois and G. Lechevallier-Chevignard, *La biscuit de Sèvres: Recueil de modèles de la manufacture de Sèvres*. Paris, 1913–14.

SHORT BIBLIOGRAPHY

L. Réau, *Etienne-Maurice Falconet*. Paris, 1922.

H. Haug, *Les faïences et porcelaines de Strasbourg*. Strasburg, 1922.

William King, *Catalogue of the Jones Collection* (Victoria and Albert Museum): *Ceramics*. London, 1924.

*Paul Alfassa and Jacques Guérin, *Porcelaine française du XVII^e au milieu du XIX^e siècle*. Paris, 1930.

E. J. Soil de Moriamé, *La Manufacture Impériale et Royale de Porcelaine de Tournay* (second edition, prepared by L. Delplace de Formanoir). Tournay, 1937.

*G. Fontaine, *La céramique française*. Paris, 1946.

Pierre Verlet, Serge Grandjean and Marcelle Brunet, *Sèvres*, Paris, 1954.

N. Ballu, *La Porcelaine française*. Paris, 1958.

Christiane Deroubaix, *Les Porcelaines de Tournai du Musée de Mariemont*. Mariemont, 1958.

A.-M. Marien-Dugardin, *Porcelaines de Tournai*. Musées Royaux d'Art et d'Histoire, Brussels, 1959.

George Savage, *Seventeenth and Eighteenth Century French Porcelain*. London, 1960.

Hubert Landais, *French Porcelain*. London, 1961.

S. Gauthier, André Sergène, etc., *Les Porcelainiers du XVIIIe Siècle français*. Paris, 1964.

Svend Eriksen, *Sèvres Porcelain: The James A. de Rothschild Collection at Waddesdon Manor*. Fribourg, 1968.

INDEX

INDEX

INDEX

INDEX

INDEX

INDEX

PLATES

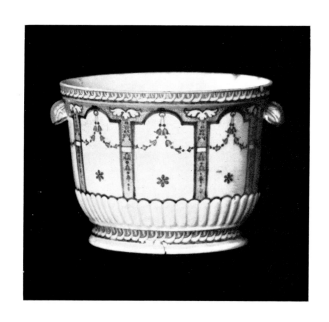

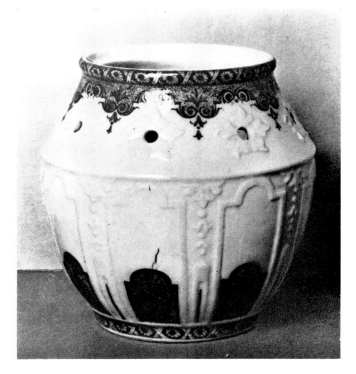

1. ROUEN

LATE-SEVENTEENTH CENTURY

A. SUGAR-BOWL, PAINTED IN UNDERGLAZE BLUE. HEIGHT, $4\frac{1}{8}$ IN.
Rouen, Musée Céramique
B. POT-POURRI VASE, PAINTED IN UNDERGLAZE BLUE. HEIGHT, 5 IN.
Mme Paul Dupuy (formerly Chavagnac Collection)
See pages 6, 7

2. SAINT-CLOUD

LATE-SEVENTEENTH OR EARLY-EIGHTEENTH CENTURY
TOILET-POT, PAINTED IN UNDERGLAZE BLUE. MARK, A SUN-FACE
IN BLUE
HEIGHT, $7\frac{3}{4}$ IN.
Victoria and Albert Museum
See pages, 9, 10, 11

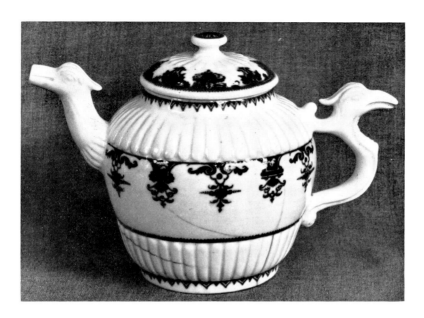

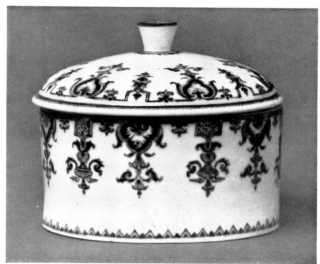

5. SAINT-CLOUD
ABOUT 1725–1735

A. TEA-POT, PAINTED IN UNDERGLAZE BLUE. MARK, 'ST C'
OVER 'T' IN BLUE
HEIGHT, $5\frac{1}{4}$ IN.
B. BUTTER-DISH, PAINTED IN UNDERGLAZE BLUE
HEIGHT, $3\frac{3}{4}$ IN.
Both Victoria and Albert Museum
See pages 9, 10, 11

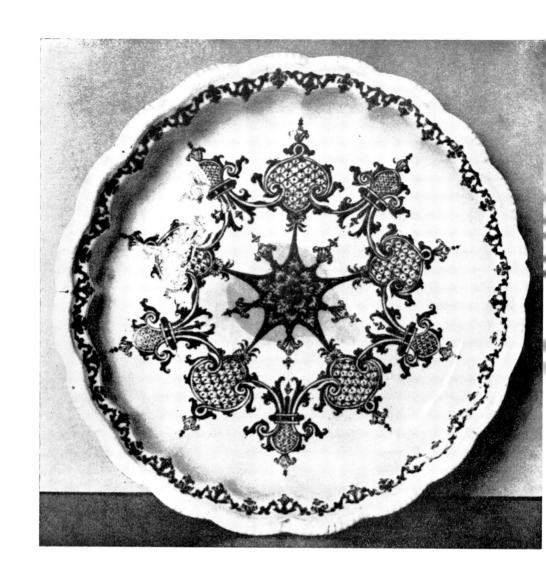

4. SAINT-CLOUD
EARLY-EIGHTEENTH CENTURY
DISH, PAINTED IN UNDERGLAZE BLUE
DIAMETER, $9\frac{3}{4}$ IN.
Musée des Arts Décoratifs
See pages 10, 11

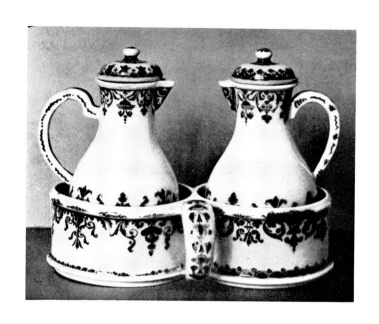

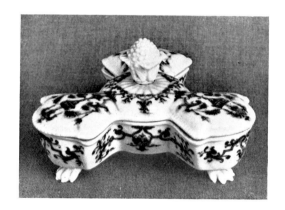

5. SAINT-CLOUD
LATE-SEVENTEENTH OR EARLY-EIGHTEENTH CENTURY

A. CRUET, PAINTED IN UNDERGLAZE BLUE. MARK, 'AP' AND
A STAR IN BLUE
HEIGHT, 5 IN.
Gilbert Lévy (formerly Chavagnac Collection)
B. SPICE-BOX, PAINTED IN UNDERGLAZE BLUE
HEIGHT, $3\frac{7}{8}$ IN.
Victoria and Albert Museum
See pages 6, 10, 11

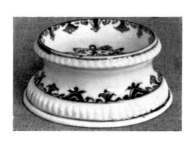

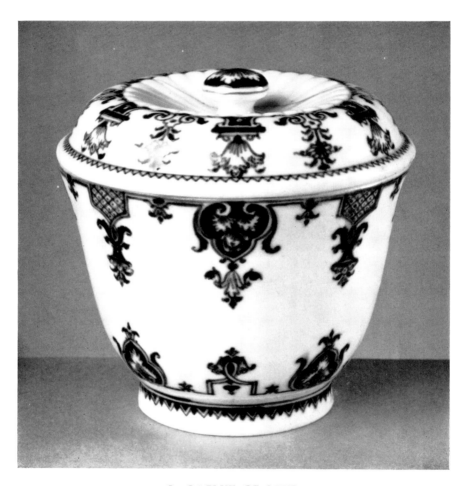

6. SAINT-CLOUD

LATE-SEVENTEENTH OR EARLY-EIGHTEENTH CENTURY

A. SALT-CELLAR, PAINTED IN UNDERGLAZE BLUE. MARK,
A SUN-FACE IN BLUE
HEIGHT, $1\frac{1}{2}$ IN.
B. POT, PAINTED IN UNDERGLAZE BLUE
HEIGHT, $4\frac{1}{4}$ IN.
Both Victoria and Albert Museum
See pages 9, 10, 11

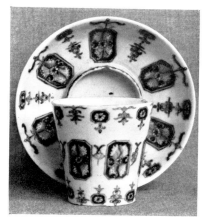
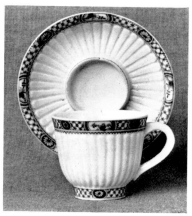
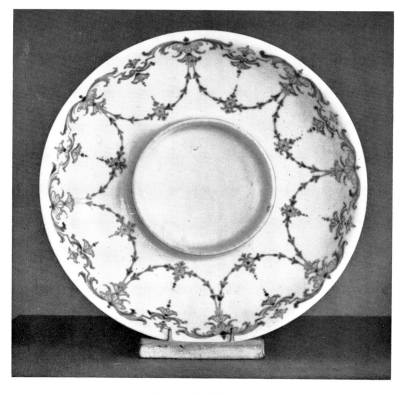

7. SAINT-CLOUD

SECOND QUARTER OF EIGHTEENTH CENTURY

A. CUP AND SAUCER, PAINTED IN UNDERGLAZE BLUE
HEIGHT OF CUP, $2\frac{7}{8}$ IN.

B. CUP AND SAUCER, PAINTED IN UNDERGLAZE BLUE. MARK,
'ST C' OVER 'T' IN BLUE. HEIGHT OF CUP, $2\frac{1}{2}$ IN.

C. SAUCER, PAINTED IN UNDERGLAZE BLUE. MARK, 'ST C'
OVER 'T' BETWEEN TWO DOTS, IN BLUE
DIAMETER, $5\frac{1}{4}$ IN.

All Victoria and Albert Museum

See pages 9, 10, 11

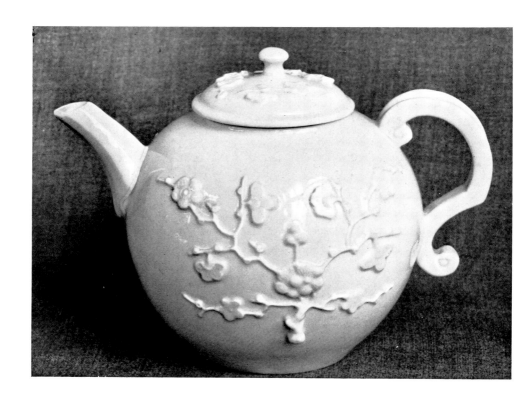

8. SAINT-CLOUD

SECOND QUARTER OF EIGHTEENTH CENTURY

TEA-POT

HEIGHT, $4\frac{3}{4}$ IN.

Victoria and Albert Museum

See page 10

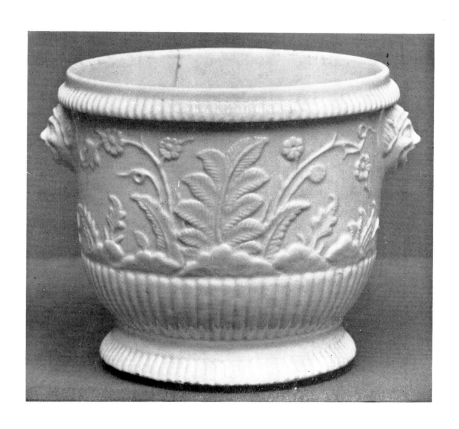

9. SAINT-CLOUD

SECOND QUARTER OF EIGHTEENTH CENTURY

FLOWER-POT
HEIGHT, $4\frac{7}{8}$ IN.
Victoria and Albert Museum
See page 10

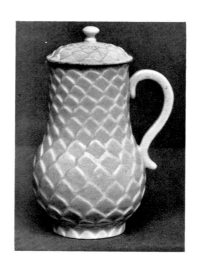

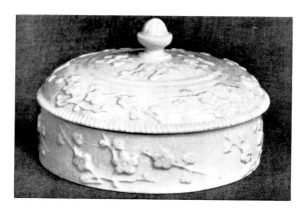

10. SAINT-CLOUD
SECOND QUARTER OF EIGHTEENTH CENTURY
A. JUG
HEIGHT, $5\frac{5}{8}$ IN.
B. BOX AND COVER
HEIGHT, $3\frac{7}{8}$ IN.
Both Victoria and Albert Museum
See page 10

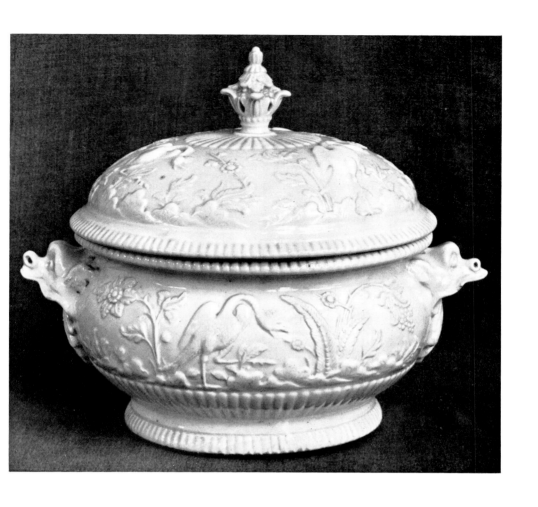

11. SAINT-CLOUD
SECOND QUARTER OF EIGHTEENTH CENTURY
TUREEN
HEIGHT, 10 IN.
Victoria and Albert Museum
See page 10

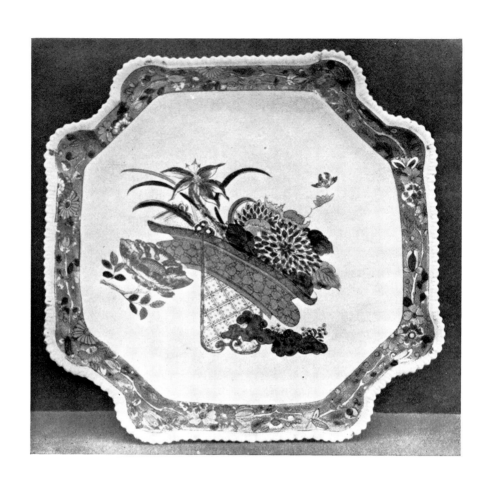

12. SAINT-CLOUD

ABOUT 1725

DISH, PAINTED IN THE COLOURS OF THE CHINESE
'FAMILLE VERTE'

WIDTH, 9 IN.

Maurice Lobre (formerly Fitzhenry Collection)

See page 12

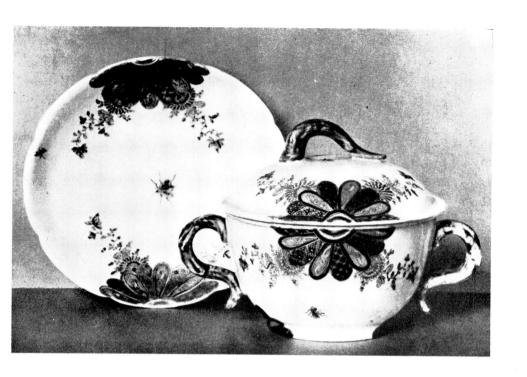

13. SAINT-CLOUD

SECOND QUARTER OF EIGHTEENTH CENTURY

BOWL, COVER AND STAND, PAINTED IN JAPANESE ('IMARI')
STYLE IN BLUE, RED AND GILT
DIAMETER OF STAND, $6\frac{1}{2}$ IN.
Musée des Arts Décoratifs
See page 12

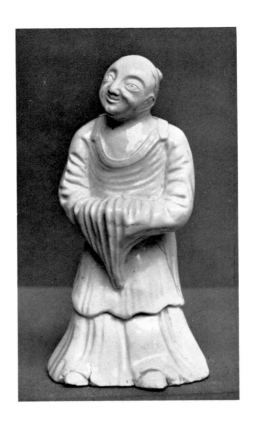

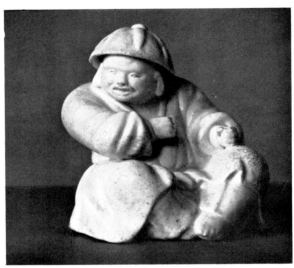

14. SAINT-CLOUD

SECOND QUARTER OF EIGHTEENTH CENTURY

A. FIGURE OF A STANDING CHINAMAN, GLAZED WHITE PORCELAIN
HEIGHT, $8\frac{7}{8}$ IN.

B. FIGURE OF A SEATED CHINAMAN, GLAZED WHITE PORCELAIN
HEIGHT, $5\frac{1}{2}$ IN.

Both Victoria and Albert Museum

See page 11

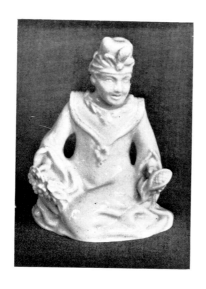

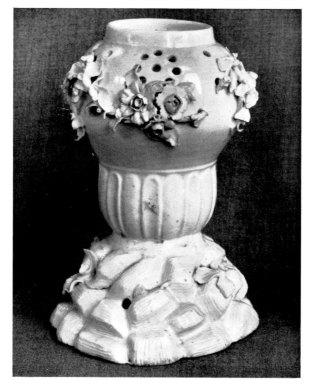

15. SAINT-CLOUD
MIDDLE OF EIGHTEENTH CENTURY
A. FIGURE OF A CHINESE WOMAN, GLAZED WHITE PORCELAIN
HEIGHT, $5\frac{1}{8}$ IN.
B. PASTILLE-BURNER, GLAZED WHITE PORCELAIN
HEIGHT, $7\frac{1}{8}$ IN.
Both Victoria and Albert Museum
See page 11

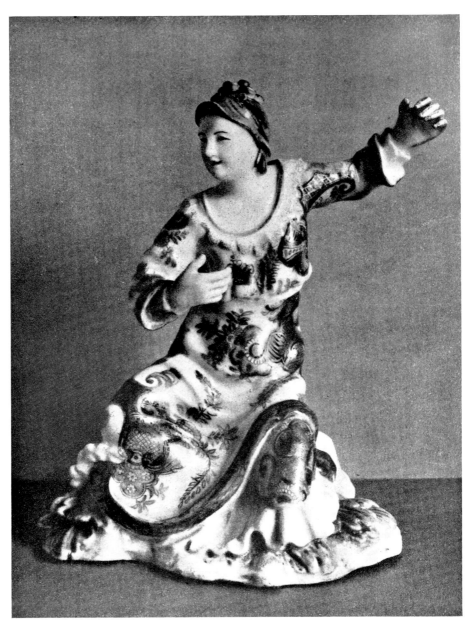

16. SAINT-CLOUD

SECOND QUARTER OF EIGHTEENTH CENTURY

FIGURE OF A SEATED CHINAMAN, PAINTED IN COLOURS AND GILT

HEIGHT, $8\frac{1}{4}$ IN.

Baronne Fould-Springer

See page 11

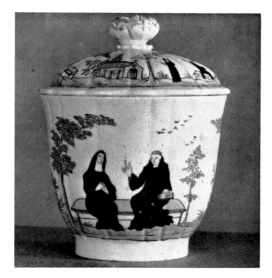

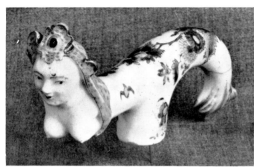

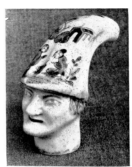

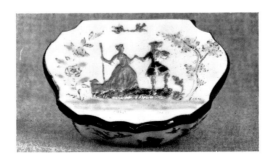

17. SAINT-CLOUD

SECOND QUARTER OF EIGHTEENTH CENTURY

A. POT, PAINTED IN COLOURS. HEIGHT, $5\frac{1}{4}$ IN.

B. CANE-HANDLE, PAINTED IN COLOURS. HEIGHT, $2\frac{7}{8}$ IN.

C. CANE-HANDLE, PAINTED IN COLOURS. HEIGHT, $2\frac{5}{8}$ IN.

D. SNUFF-BOX, DECORATED WITH TRANSLUCENT ENAMEL
COLOURS OVER RAISED GILDING. WIDTH, $2\frac{7}{8}$ IN.

All Victoria and Albert Museum
See pages 10–12, 39

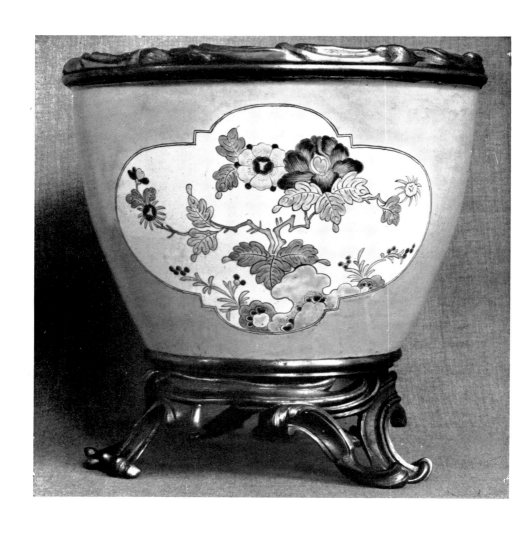

18. CHANTILLY

SECOND QUARTER OF EIGHTEENTH CENTURY

BOWL, TIN-GLAZED, PAINTED IN COLOURS IN JAPANESE
(KAKIEMON) STYLE; YELLOW GROUND. ORMOLU MOUNT
HEIGHT, $9\frac{3}{4}$ IN.

Victoria and Albert Museum

See page 14

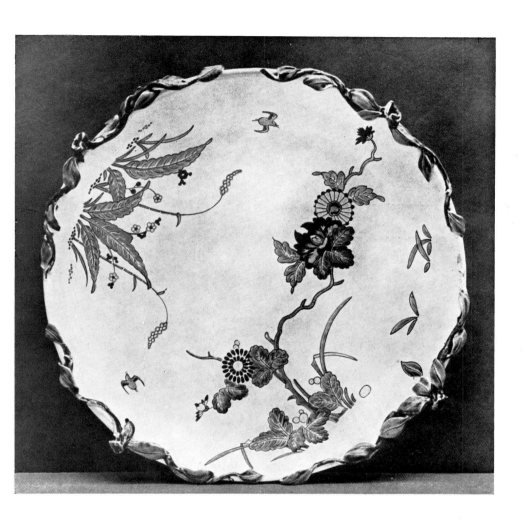

19. CHANTILLY

SECOND QUARTER OF EIGHTEENTH CENTURY

DISH, TIN-GLAZED, PAINTED IN COLOURS IN JAPANESE
(KAKIEMON) STYLE. MARK, A HUNTING-HORN IN RED
DIAMETER, 12 IN.

Mme Hallé

See pages 14, 15

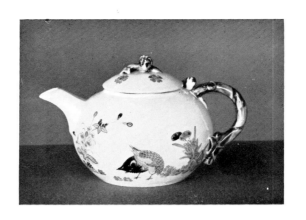

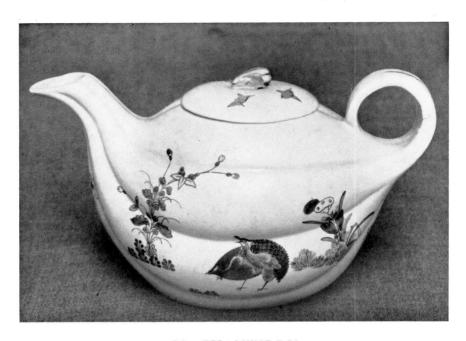

20. CHANTILLY
SECOND QUARTER OF EIGHTEENTH CENTURY

A. TEA-POT, TIN-GLAZED, PAINTED IN COLOURS IN JAPANESE
(KAKIEMON) STYLE. MARK, A HUNTING-HORN IN RED
HEIGHT, $3\frac{1}{8}$ IN.
Victoria and Albert Museum

B. TEA-POT, TIN-GLAZED, PAINTED IN COLOURS IN JAPANESE
(KAKIEMON) STYLE
HEIGHT, 4 IN.
Bedford, Cecil Higgins Museum
See pages 14, 15

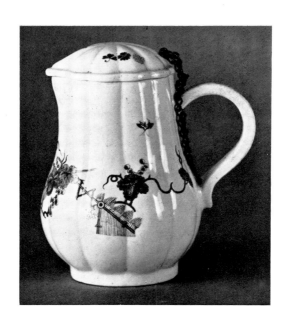

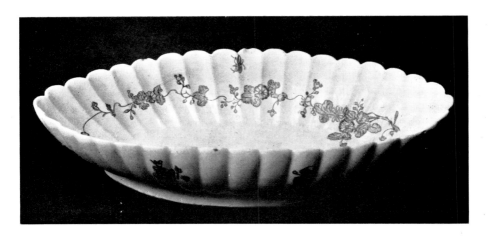

21. CHANTILLY

SECOND QUARTER OF EIGHTEENTH CENTURY

A. JUG, TIN-GLAZED, PAINTED IN COLOURS IN JAPANESE
(KAKIEMON) STYLE. MARK, A HUNTING-HORN IN RED
HEIGHT, $4\frac{3}{8}$ IN.
Victoria and Albert Museum

B. DISH, TIN-GLAZED, PAINTED IN COLOURS IN JAPANESE
(KAKIEMON) STYLE
WIDTH, $8\frac{1}{4}$ IN.
British Museum
See pages 14, 15

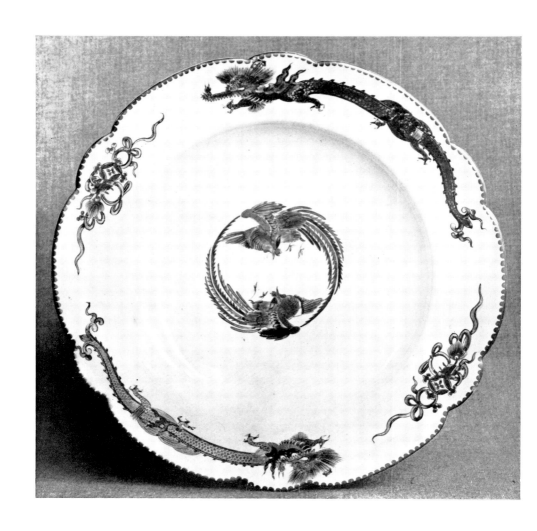

22. CHANTILLY

SECOND QUARTER OF EIGHTEENTH CENTURY

PLATE, TIN-GLAZED, PAINTED IN COLOURS IN JAPANESE
(KAKIEMON) STYLE. MARK, A HUNTING-HORN AND 'B', IN
GOLD (?) OVER REDDISH BROWN: COMPARE PAGE 55
DIAMETER, $9\frac{1}{2}$ IN.

Victoria and Albert Museum

See page 14

23. CHANTILLY
SECOND QUARTER OF EIGHTEENTH CENTURY
TOILET-POT, TIN-GLAZED, PAINTED IN COLOURS IN JAPANESE
(KAKIEMON) STYLE
HEIGHT, $6\frac{7}{8}$ IN.
Victoria and Albert Museum
See pages 14, 15

24. CHANTILLY
SECOND QUARTER OF EIGHTEENTH CENTURY
DRUG-POT, TIN-GLAZED, PAINTED IN COLOURS. MARK, A
HUNTING-HORN IN RED
HEIGHT, $5\frac{7}{8}$ IN.
Victoria and Albert Museum
See page 15

25. CHANTILLY

MIDDLE OF EIGHTEENTH CENTURY

JUG, TIN-GLAZED, PAINTED IN COLOURS. MARK, A HUNTING-
HORN AND 'A' IN RED

HEIGHT, $6\frac{3}{8}$ IN.

Victoria and Albert Museum

See pages 15, 16

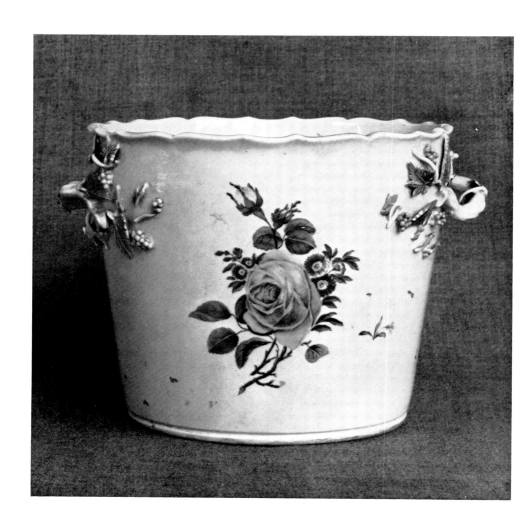

26. CHANTILLY

MIDDLE OF EIGHTEENTH CENTURY

FLOWER-POT, TIN-GLAZED, PAINTED IN COLOURS

HEIGHT, $5\frac{1}{2}$ IN.

Victoria and Albert Museum

See page 16

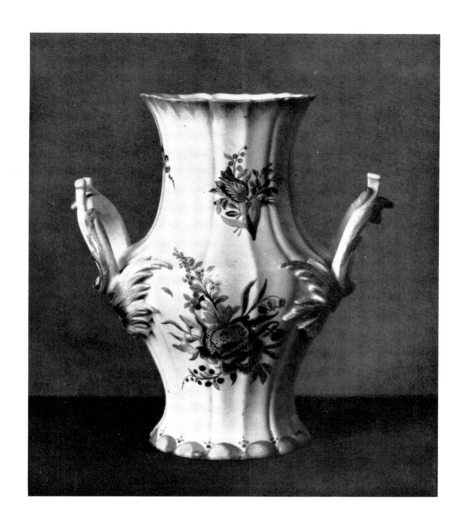

27. CHANTILLY
MIDDLE OF EIGHTEENTH CENTURY
VASE, TIN-GLAZED, PAINTED IN COLOURS. MARK, A HUNTING-
HORN IN RED
HEIGHT, $7\frac{1}{8}$ IN.
Victoria and Albert Museum
See page 16

28. CHANTILLY
SECOND QUARTER OF EIGHTEENTH CENTURY
A. CANE-HANDLE, TIN-GLAZED, PAINTED IN COLOURS
HEIGHT, $2\frac{1}{2}$ IN.
Victoria and Albert Museum
B. FIGURE, TIN-GLAZED, PAINTED IN COLOURS
HEIGHT, $6\frac{3}{4}$ IN.
Musée de Cluny
See pages 15, 16

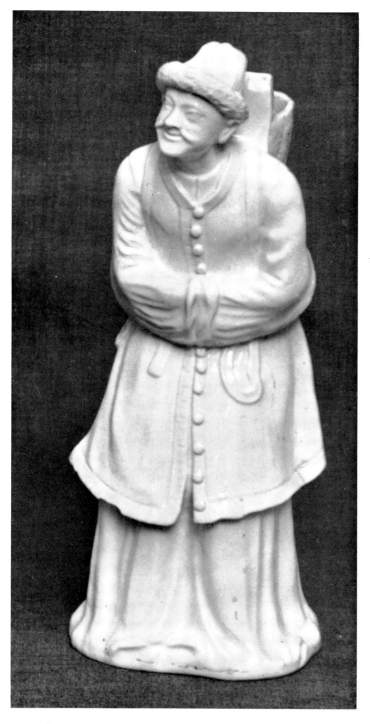

29. CHANTILLY
ABOUT 1745

FIGURE, TIN-GLAZED, PAINTED IN COLOURS
HEIGHT, 11 IN.
Bedford, Cecil Higgins Museum
See page 15

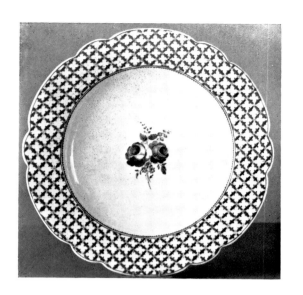

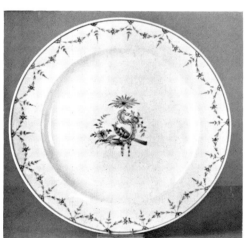
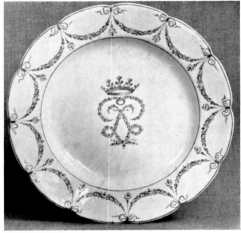

30. CHANTILLY

THIRD QUARTER OF EIGHTEENTH CENTURY

A. PLATE, TIN-GLAZED, PAINTED IN BLUE ENAMEL. MARK, A
HUNTING-HORN AND 'C' IN BLUE ENAMEL
DIAMETER, $9\frac{3}{4}$ IN.

B. PLATE, PAINTED IN UNDERGLAZE BLUE. MARK, A HUNTING-
HORN AND 'P' IN UNDERGLAZE BLUE
DIAMETER, $9\frac{1}{2}$ IN.

C. PLATE, TIN-GLAZED, PAINTED IN BLUE ENAMEL, WITH THE
INTERLACED INITIALS OF LOUIS-PHILIPPE, DUKE OF ORLEANS
(1752–85). MARK, A HUNTING-HORN AND 'R', ALSO 'VILLERS-
COTTERETS', ALL IN BLUE ENAMEL
DIAMETER, $9\frac{1}{4}$ IN.

All Victoria and Albert Museum
See pages 13, 17

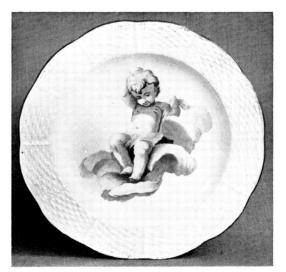

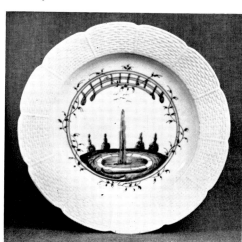
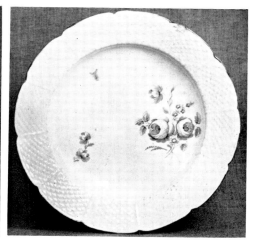

31. CHANTILLY

THIRD QUARTER OF EIGHTEENTH CENTURY

A. PLATE, TIN-GLAZED, PAINTED IN PURPLE. MARK, A HUNTING-
HORN IN BLUE ENAMEL
DIAMETER, $9\frac{1}{4}$ IN.

B. PLATE, PAINTED IN UNDERGLAZE BLUE. MARK, A HUNTING-
HORN AND 'C' IN UNDERGLAZE BLUE
DIAMETER, $9\frac{5}{8}$ IN.

C. PLATE, TIN-GLAZED, PAINTED IN BLUE ENAMEL. MARK, A
HUNTING-HORN AND 'L' IN BLUE ENAMEL
DIAMETER, $9\frac{1}{8}$ IN.

All Victoria and Albert Museum

See pages 16, 17

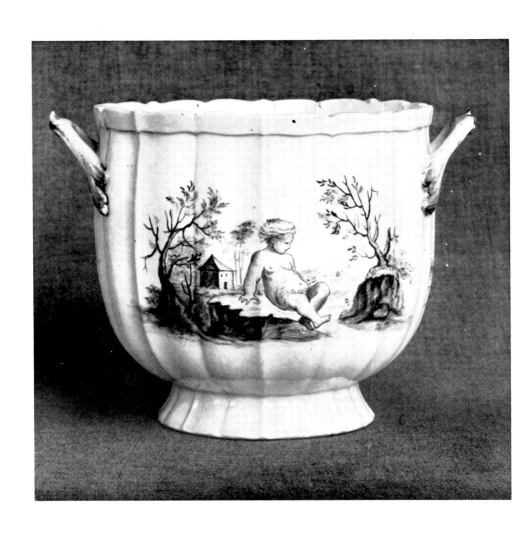

52. CHANTILLY

THIRD QUARTER OF EIGHTEENTH CENTURY
FLOWER-POT, TIN-GLAZED, PAINTED IN PURPLE. MARK,
A HUNTING-HORN IN RED
HEIGHT, $5\frac{3}{4}$ IN.
Victoria and Albert Museum
See page 16

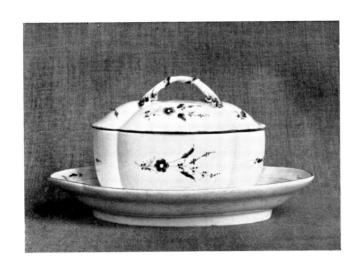

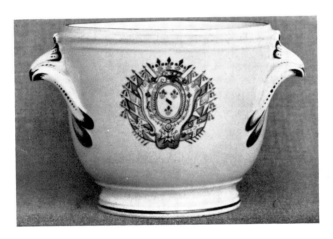

35. CHANTILLY

THIRD QUARTER OF EIGHTEENTH CENTURY

A. SUGAR-BASIN, TIN-GLAZED, PAINTED IN BLUE ENAMEL
MARK, A HUNTING-HORN AND 'A' IN BLUE; ALSO ON THE
STAND 'CABIN' INCISED
WIDTH, $5\frac{5}{8}$ IN.

B. FLOWER-POT, TIN-GLAZED, PAINTED WITH THE ARMS OF THE
PRINCE DE CONDÉ, IN BLUE ENAMEL. MARK, A HUNTING-HORN
AND 'P' IN BLUE
HEIGHT, 4 IN.

Both Victoria and Albert Museum
See pages 14, 17, 55

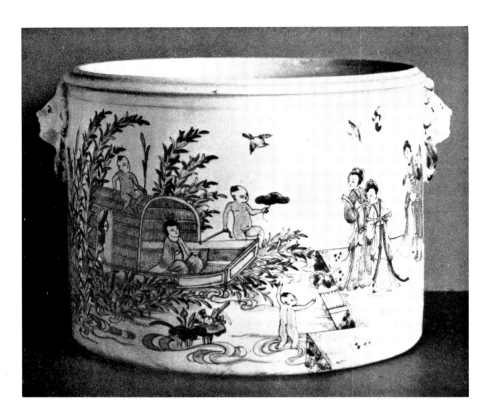

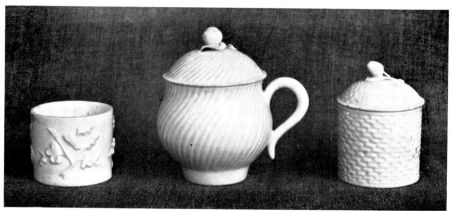

34. MENNECY

SECOND QUARTER OF EIGHTEENTH CENTURY

A. ICE-POT, TIN-GLAZED, PAINTED IN COLOURS IN CHINESE STYLE
ABOUT 1735. HEIGHT, $6\frac{1}{4}$ IN.

Mme Hallé

B, C, D. CUSTARD-CUP AND POMADE-POTS. MARK ON EACH
'D, V,' INCISED

HEIGHT, $1\frac{5}{8}$, $3\frac{3}{8}$, $2\frac{5}{8}$ IN. RESPECTIVELY

Victoria and Albert Museum

See pages 20, 21

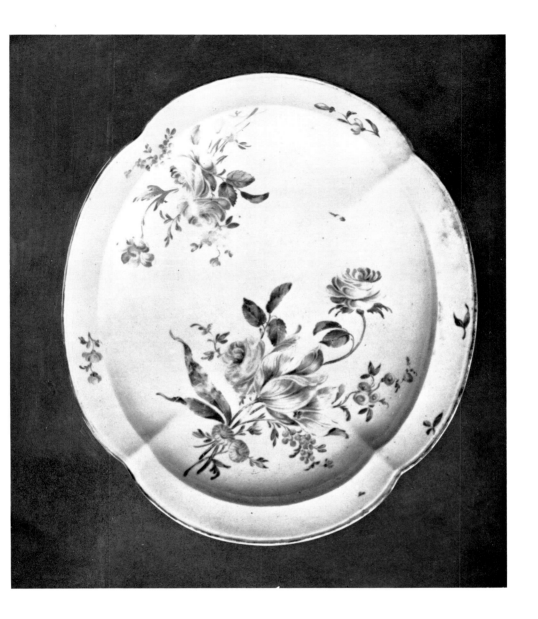

35. MENNECY

MIDDLE OF EIGHTEENTH CENTURY

DISH, PAINTED IN COLOURS. MARK, 'D, V' INCISED

LENGTH, $9\frac{1}{2}$ IN.

Victoria and Albert Museum

See page 22

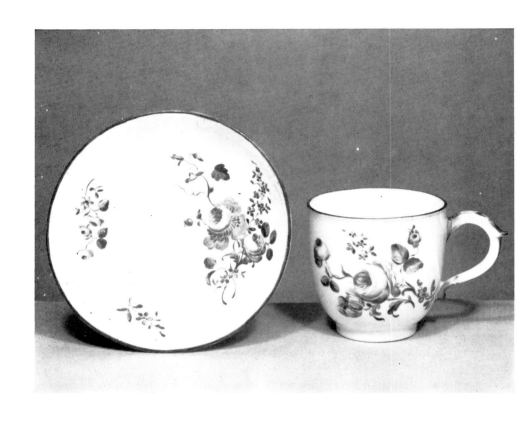

56. MENNECY

MIDDLE OF EIGHTEENTH CENTURY

CUP AND SAUCER, PAINTED IN COLOURS
MARK, 'DV' INCISED ON BOTH
HEIGHT OF CUP $2\frac{3}{4}$ IN.
DIAMETER OF SAUCER $4\frac{3}{4}$ IN.
The Earl Spencer
See page 22

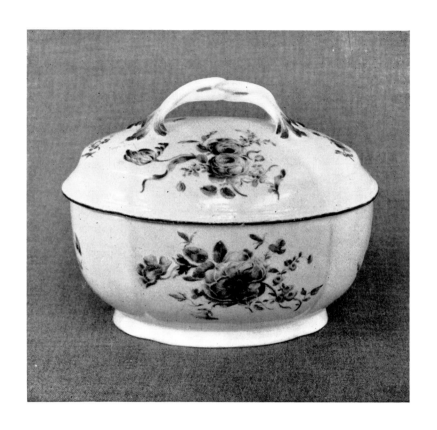

57. MENNECY

MIDDLE OF EIGHTEENTH CENTURY

BOWL AND COVER, PAINTED IN COLOURS. MARK, 'D V' INCISED

LENGTH, $5\frac{3}{4}$ IN.

J. L. Dixon

See page 22

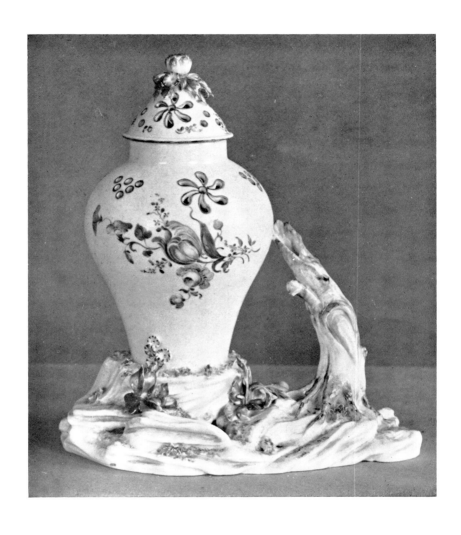

38. MENNECY
MIDDLE OF EIGHTEENTH CENTURY
PASTILLE-BURNER, PAINTED IN COLOURS. MARK, 'D: V:' INCISED
HEIGHT, $8\frac{1}{8}$ IN.
Victoria and Albert Museum
See page 22

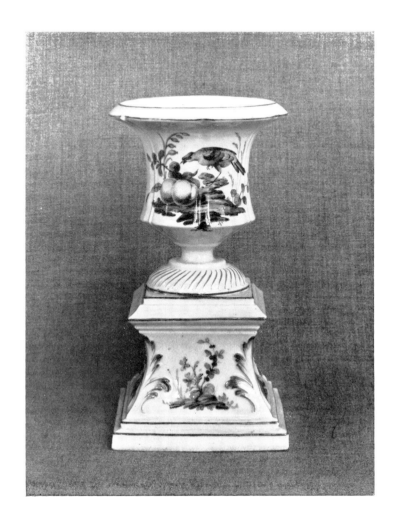

39. MENNECY

MIDDLE OF EIGHTEENTH CENTURY

VASE, PAINTED IN COLOURS. MARK, 'D. V.' INCISED

HEIGHT, 7 IN.

Victoria and Albert Museum

See pages 21, 22

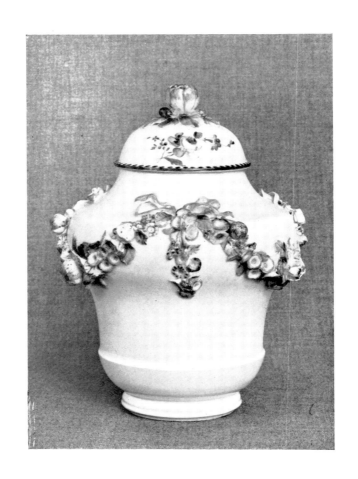

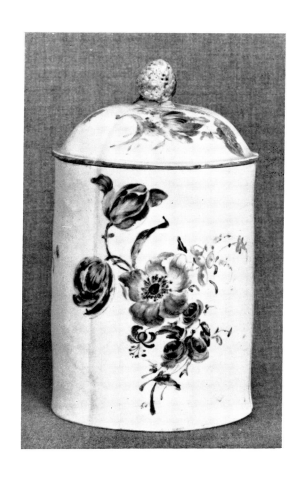

41. MENNECY OR CRÉPY-EN-VALOIS
ABOUT 1765

TOILET-POT, PAINTED IN COLOURS. MARK, 'D, C, P,' INCISED
HEIGHT, $6\frac{3}{8}$ IN.
Victoria and Albert Museum
See pages 20, 23

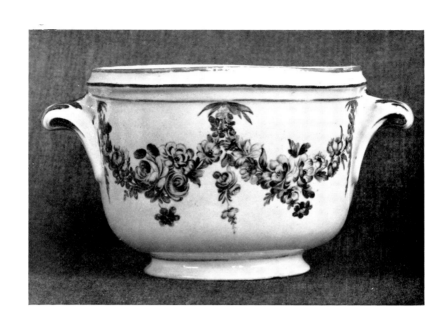

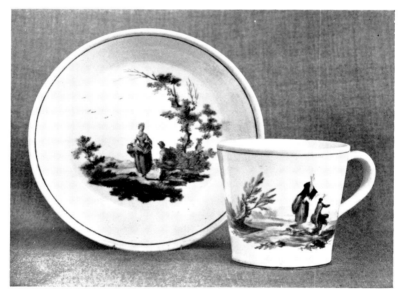

42. SCEAUX AND MENNECY
ABOUT 1760–70

A. FLOWER-POT, PAINTED IN COLOURS. SCEAUX
HEIGHT, $4\frac{5}{8}$ IN.

B. CUP AND SAUCER, PAINTED IN COLOURS. MARK, 'D, V,'
INCISED. MENNECY
HEIGHT OF CUP, $2\frac{1}{4}$ IN.

Both Victoria and Albert Museum
See pages 21–23

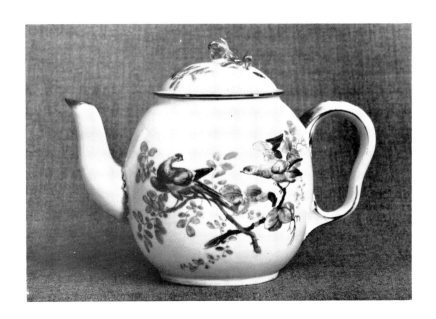

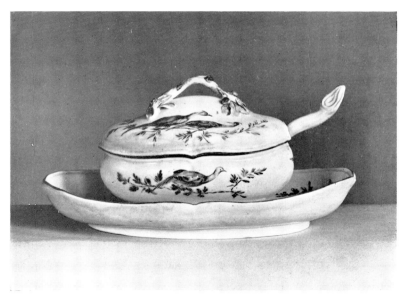

43. MENNECY AND BOURG-LA-REINE
ABOUT 1760–75
A. TEA-POT, PAINTED IN COLOURS. MARK, 'D, V,' INCISED
MENNECY. HEIGHT, $4\frac{1}{4}$ IN.
B. SUGAR-BASIN, PAINTED IN COLOURS. MARK, 'B R' INCISED
BOURG-LA-REINE
LENGTH, $9\frac{3}{4}$ IN.
Both Victoria and Albert Museum
See pages 21–23

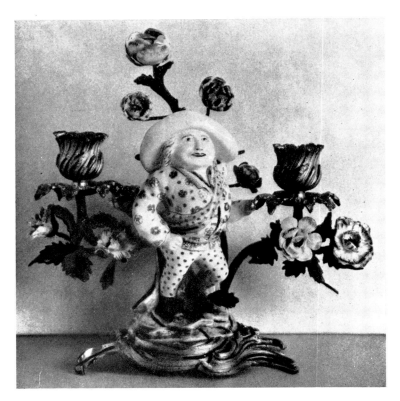

44. MENNECY

ABOUT 1735–50

A. FIGURE OF A CHINESE LADY, PAINTED IN COLOURS
HEIGHT, 4 IN.
Miss Margaret Gould
B. FIGURE OF A DWARF, PAINTED IN COLOURS AND MOUNTED
IN ORMOLU. HEIGHT, 9 IN.
M. Jacques Seligmann fils et Cie
See pages 21, 22

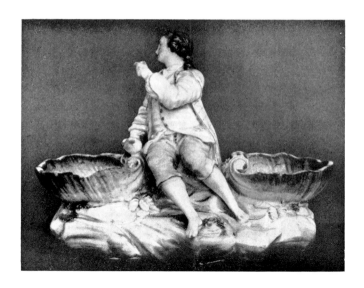

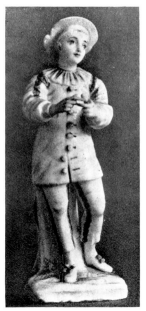
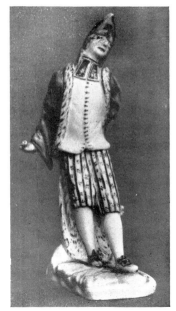

45. MENNECY

A. SWEETMEAT DISH WITH FIGURE, PAINTED IN COLOURS
MARK, 'D V' AND 'C K' INCISED
ABOUT 1750–60
HEIGHT, 6 IN.
Rodolphe Darblay
B. FIGURES FROM THE ITALIAN COMEDY, PAINTED IN COLOURS
MARK, 'D V' INCISED. ABOUT 1740–50
HEIGHT, $8\frac{1}{8}$ IN. AND $8\frac{5}{8}$ IN.
Mme la Comtesse Emmanuel de La Rochefoucauld
See pages 21, 22

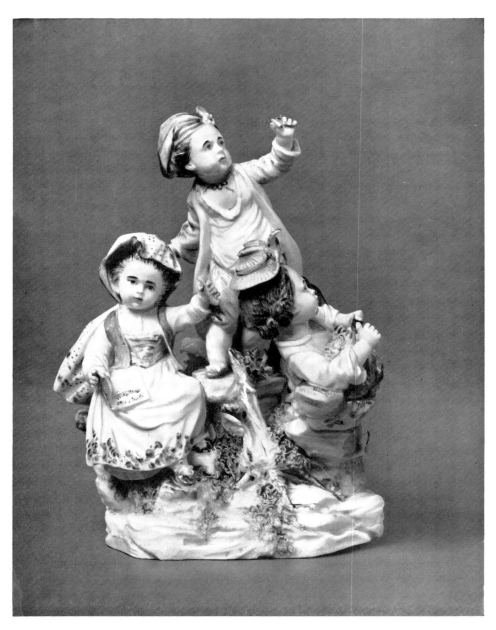

46. MENNECY
ABOUT 1760

GROUP, PAINTED IN COLOURS
HEIGHT, $9\frac{1}{2}$ IN.
Victoria and Albert Museum
See page 21

47. MENNECY
ABOUT 1760

A. SWEETMEAT DISH, PAINTED IN COLOURS
MARK, 'D. V.' INCISED
HEIGHT, $4\frac{3}{4}$ IN.
B. GROUP, PAINTED IN COLOURS. MARK, 'D. V' INCISED
HEIGHT, $5\frac{5}{8}$ IN.
Both Victoria and Albert Museum
See pages 21, 24

48. MENNECY

ABOUT 1755

FIGURE OF A RIVER-GOD, GLAZED WHITE PORCELAIN, FROM A
MODEL BY NICOLAS GAURON. MARKS, 'D, V' INCISED AND
'B R' (?) IN BLUE

HEIGHT, 6½ IN.

Victoria and Albert Museum

See page 21

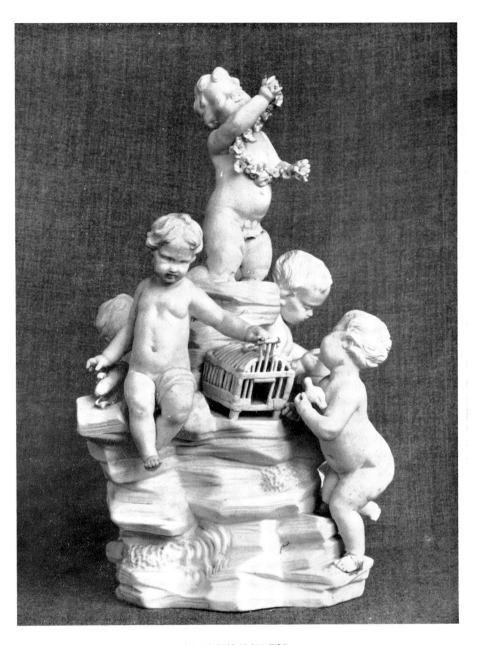

49. MENNECY
ABOUT 1770

GROUP, BISCUIT PORCELAIN. MARK, 'DV, MO' INCISED
HEIGHT, $9\frac{5}{8}$ IN.
Victoria and Albert Museum
See page 22

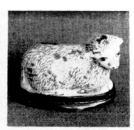
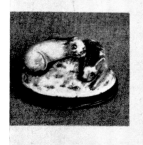
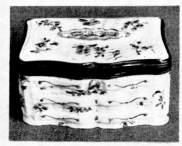
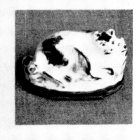
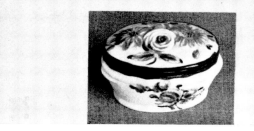

50. SAINT-CLOUD AND MENNECY SNUFF-BOXES

SECOND QUARTER AND MIDDLE OF EIGHTEENTH CENTURY

ALL PAINTED IN COLOURS

A. SAINT-CLOUD. THE SILVER MOUNT BEARS THE PARIS HALL-MARK FOR 1732–38. LENGTH, $2\frac{7}{8}$ IN.

B. SAINT-CLOUD. LENGTH, $2\frac{3}{4}$ IN.

C. SAINT-CLOUD. THE SILVER MOUNT BEARS THE PARIS HALL-MARK FOR 1738–39. LENGTH, $2\frac{1}{4}$ IN.

D. SAINT-CLOUD. LENGTH, $2\frac{1}{2}$ IN.

E. MENNECY (?). LENGTH, 2 IN.

F. MENNECY. MARK, 'D. V.' IN GREY. LENGTH, $3\frac{1}{4}$ IN.

G. MENNECY. LENGTH, $2\frac{1}{8}$ IN. H. MENNECY. LENGTH, $2\frac{1}{4}$ IN.

All Victoria and Albert Museum

See pages 10, 12, 23

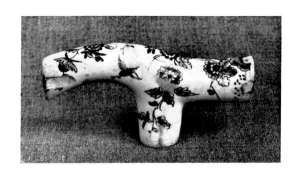

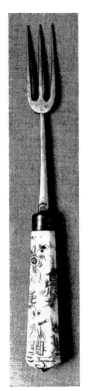 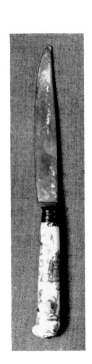 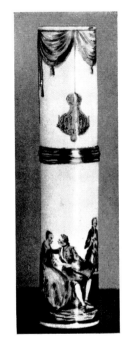 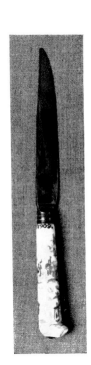 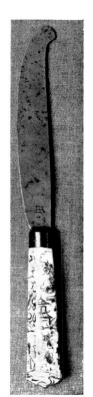

51. SAINT-CLOUD, CHANTILLY, MENNECY AND VINCENNES

SECOND QUARTER OF EIGHTEENTH CENTURY

ALL PAINTED IN COLOURS

A. CANE-HANDLE. MARK, 'D. V.' IN RED. MENNECY. ABOUT 1735
LENGTH, $4\frac{7}{8}$ IN.

B, F. KNIFE AND FORK. CHANTILLY. LENGTH, $9\frac{1}{2}$ IN.

C, E. KNIVES PAINTED IN BLUE, PALE RED AND GILT. SAINT-
CLOUD. LENGTH, $7\frac{5}{8}$ IN.

D. NEEDLE-CASE. VINCENNES; ABOUT 1750. LENGTH, $4\frac{3}{4}$ IN.

D, *M. Founès* (*formerly Doistau Collection*);
the others, Victoria and Albert Museum
See pages 12, 16, 23, 32

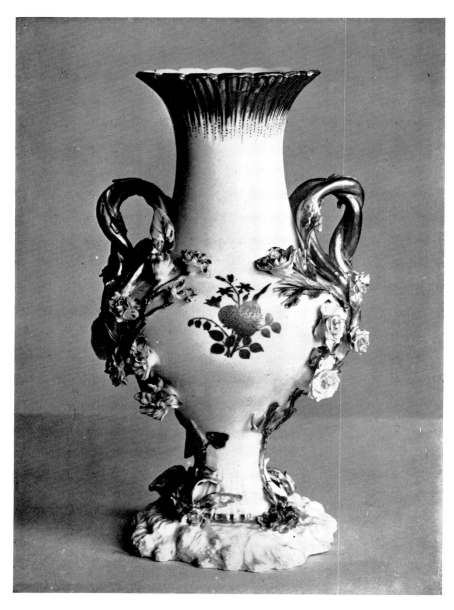

52. VINCENNES
ABOUT 1745–50

VASE WITH APPLIED FLOWERS, PAINTED IN GILT
HEIGHT, 9 IN.
Victoria and Albert Museum
See page 34

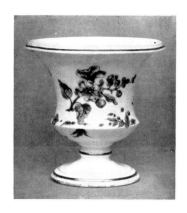

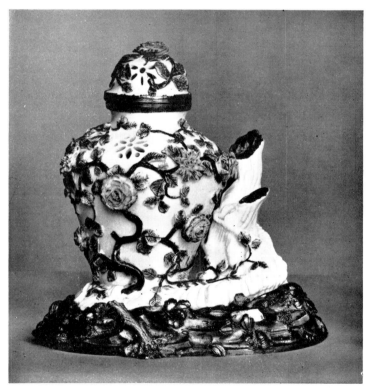

53. VINCENNES
ABOUT 1745–50

A. VASE FOR MODELLED FLOWERS, PAINTED IN COLOURS
MARK, CROSSED 'L'S' ENCLOSING A DOT IN BLUE
HEIGHT, $4\frac{5}{8}$ IN.
British Museum

B. PASTILLE-BURNER WITH APPLIED FLOWERS, PAINTED IN
COLOURS AND MOUNTED IN ORMOLU. HEIGHT, $10\frac{1}{2}$ IN.
Victoria and Albert Museum
See pages 31, 34

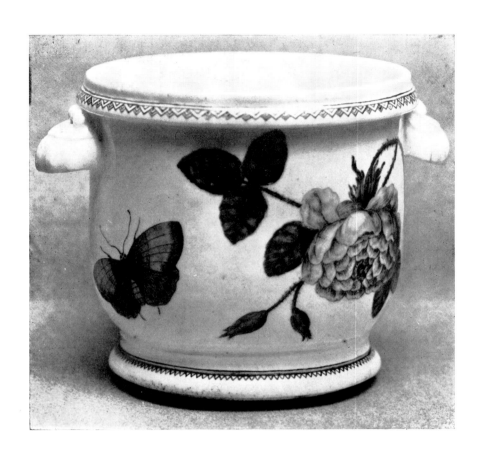

54. VINCENNES
ABOUT 1745–50

FLOWER-POT, PAINTED IN COLOURS. MARK, CROSSED 'L'S'
IN BLUE

HEIGHT, $4\frac{3}{4}$ IN.

Formerly Fitzhenry Collection

See page 31

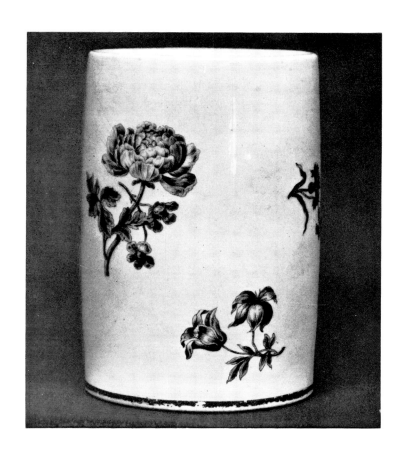

55. VINCENNES
ABOUT 1745–50
TOILET-POT, PAINTED IN COLOURS. MARK, CROSSED 'L'S'
IN BLUE
HEIGHT, $5\frac{3}{4}$ IN.
Victoria and Albert Museum
See page 31

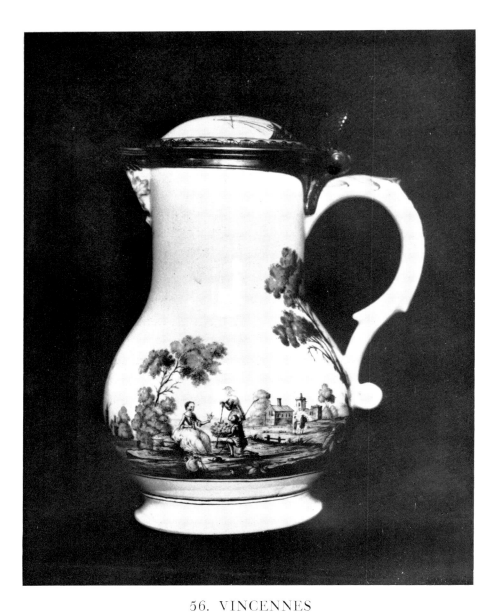

56. VINCENNES

ABOUT 1745–50

JUG, PAINTED IN COLOURS AND GILT. MARK, CROSSED
'L'S' IN BLUE

HEIGHT, $6\frac{1}{4}$ IN.

Private Collection

See pages 16, 31

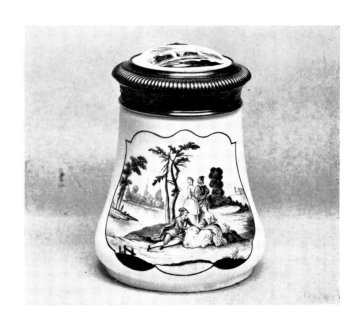

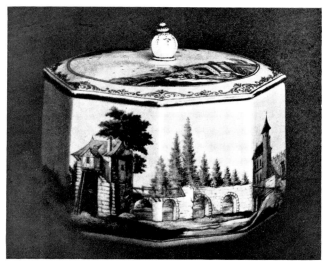

57. VINCENNES
ABOUT 1745–50

A. TEA-JAR, PAINTED IN COLOURS AND GILT
HEIGHT, $5\frac{1}{2}$ IN.
L. Marcel

B. SUGAR-BOWL, PAINTED IN COLOURS AND GILT
MARK, CROSSED 'L'S' IN GILT
HEIGHT, 4 IN.
Gilbert Lévy
See page 31

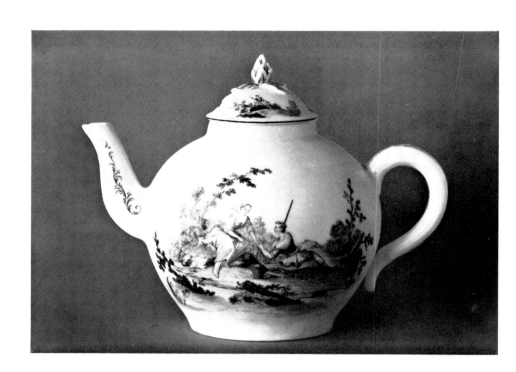

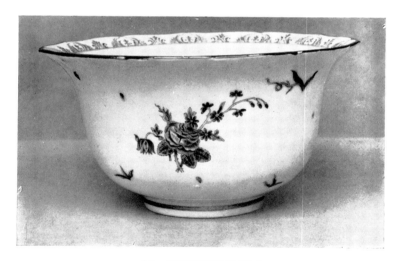

58. VINCENNES

ABOUT 1750

A. TEA-POT, PAINTED IN COLOURS
HEIGHT, $5\frac{1}{2}$ IN.
Victoria and Albert Museum
B. BOWL, PAINTED IN COLOURS. MARK, CROSSED 'L'S' AND
A DOT IN BLUE. DIAMETER, $6\frac{1}{4}$ IN.
British Museum
See pages 31, 33

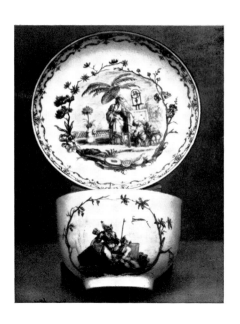

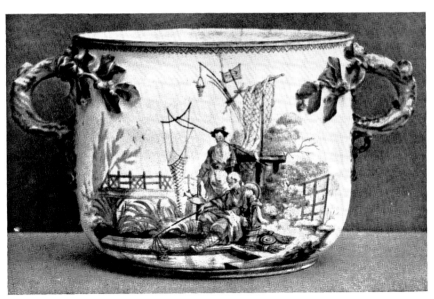

59. VINCENNES

ABOUT 1750

A. CUP AND SAUCER, PAINTED IN COLOURS
HEIGHT OF CUP, $4\frac{1}{4}$ IN.
E. S. McEuen

B. FLOWER-POT, PAINTED IN COLOURS
HEIGHT, $4\frac{3}{4}$ IN.
Miss Margaret Gould
See page 31

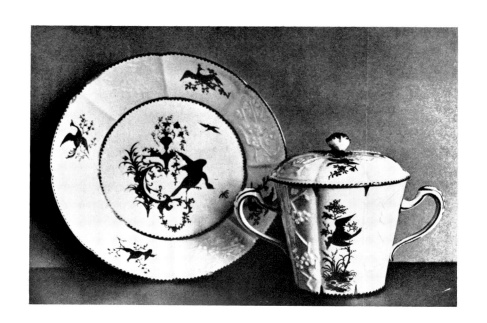

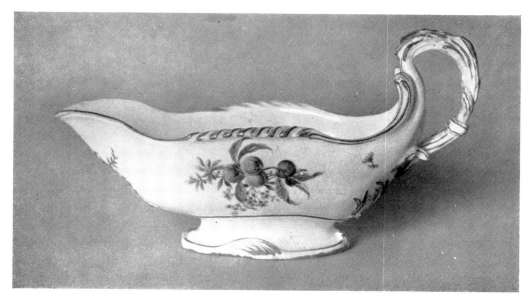

60. VINCENNES
ABOUT 1750–55

A. CUP AND SAUCER, PAINTED IN GILT. MARK, CROSSED 'L'S'
AND FIVE DOTS IN BLUE
HEIGHT OF CUP, $4\frac{1}{4}$ IN.
B. SAUCE-BOAT, PAINTED IN COLOURS AND GILT
MARK, CROSSED 'L'S' IN BLUE
LENGTH, $8\frac{1}{2}$ IN.
Both Musée des Arts Décoratifs
See pages 31–33

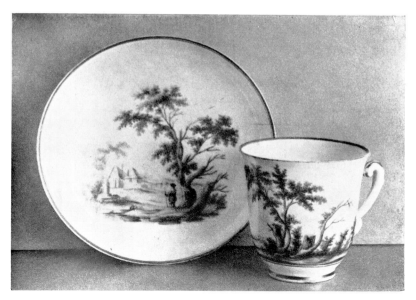

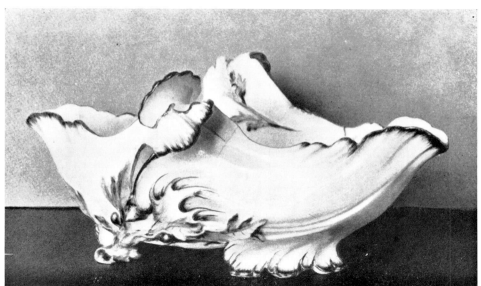

61. VINCENNES
ABOUT 1750–56

A. CUP AND SAUCER, PAINTED IN GREEN MONOCHROME
MARK, CROSSED 'L'S' ENCLOSING A DOT IN BLUE
HEIGHT OF CUP, 3 IN.
Mme. la Comtesse de Crisenoy de Lionne

B. SAUCE-BOAT, PAINTED IN COLOURS. MARK IN BLUE, CROSSED
'L'S' ENCLOSING 'D' (FOR THE YEAR 1756)
LENGTH, $10\frac{1}{8}$ IN.
Musée des Arts Décoratifs
See pages 32, 33

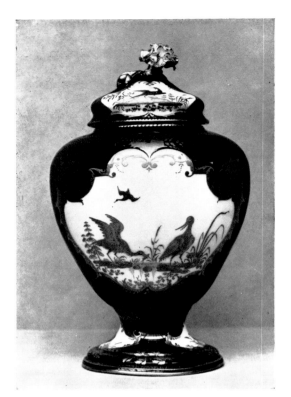

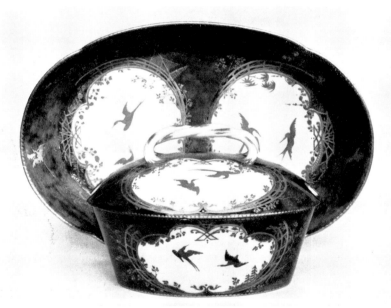

62. VINCENNES

ABOUT 1750–55

A. VASE, PAINTED IN GILT IN PANELS RESERVED ON A DARK
BLUE ('GROS BLEU') GROUND. MARK, CROSSED 'L'S' IN BLUE
HEIGHT, $9\frac{1}{4}$ IN.

B. BOWL AND STAND, PAINTED IN GILT IN PANELS RESERVED ON
A DARK BLUE ('GROS BLEU') GROUND. MARK, FOLIATED CROSSED
'L'S' WITH A 'FLEUR-DE-LYS', IN BLUE. LENGTH OF STAND, $10\frac{1}{8}$ IN.

Both British Museum. See page 33

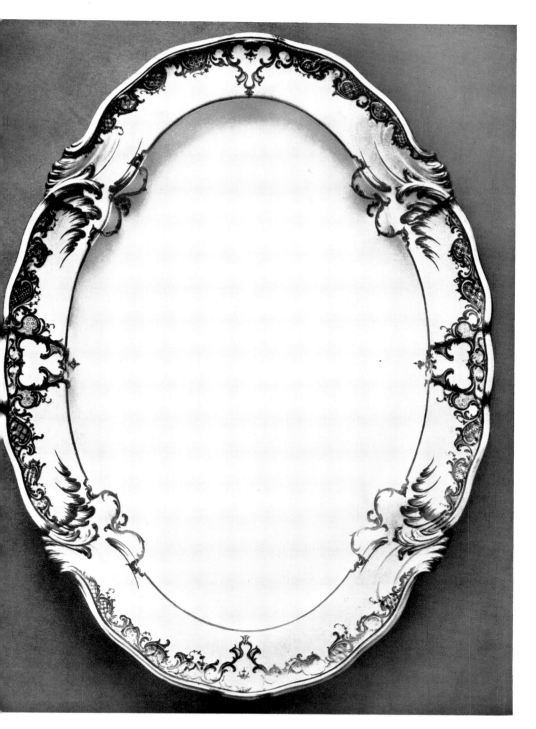

63. SÈVRES
DATED 1759

DISH, DECORATED WITH GILDING ONLY. MARK, CROSSED 'L'S'
ENCLOSING 'G' (FOR THE YEAR 1759) IN GOLD
LENGTH, $25\frac{3}{8}$ IN.
Musée des Arts Décoratifs
See page 33

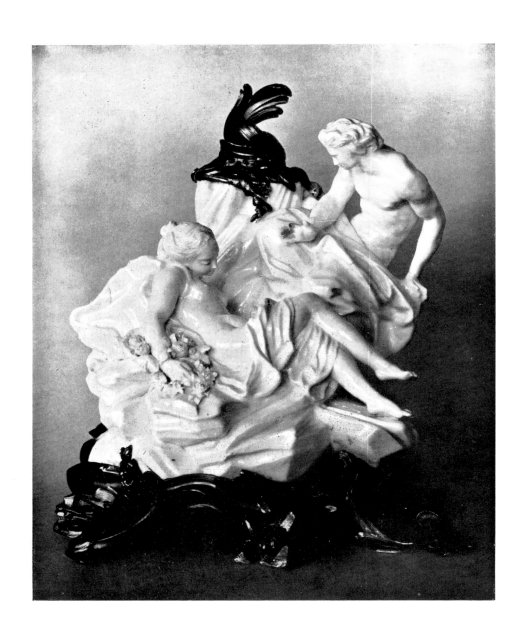

64. VINCENNES
ABOUT 1750–55

GROUP, GLAZED WHITE PORCELAIN
HEIGHT, 11⅝ IN.
Victoria and Albert Museum
See page 55

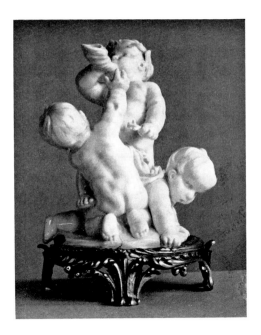

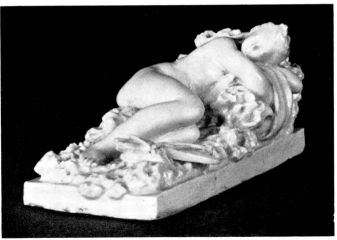

65. VINCENNES AND SÈVRES
ABOUT 1747–57

A. GROUP, GLAZED WHITE PORCELAIN FROM A MODEL MADE
BY L.-F. DE LA RUE IN 1757. HEIGHT, $9\frac{1}{4}$ IN.
B. FIGURE, GLAZED WHITE PORCELAIN, PERHAPS FROM A
MODEL MADE BY LOUIS FOURNIER ABOUT 1747
LENGTH, 6 IN.
Both Victoria and Albert Museum
See pages 34, 35

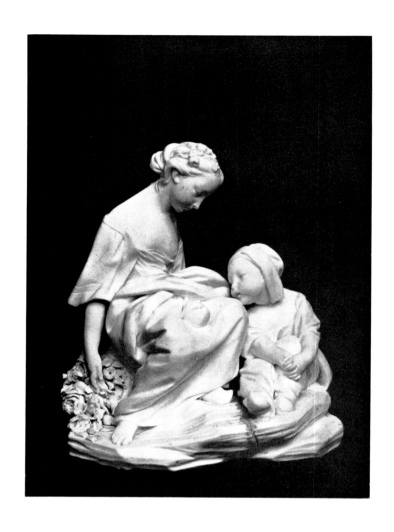

66. SÈVRES

ABOUT 1760

GROUP, BISCUIT PORCELAIN: 'LE SABOT CASSÉ,' FROM A MODEL
BY E.-M. FALCONET MADE ABOUT 1760

HEIGHT, $6\frac{1}{2}$ IN.

British Museum

See page 36

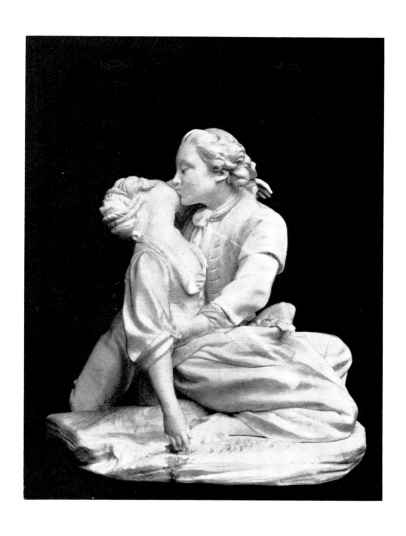

67. SÈVRES
ABOUT 1765
GROUP, BISCUIT PORCELAIN: 'LE BAISER DONNÉ,' FROM A
MODEL MADE BY E.-M. FALCONET IN 1765
HEIGHT, $6\frac{5}{8}$ IN.
British Museum
See page 36

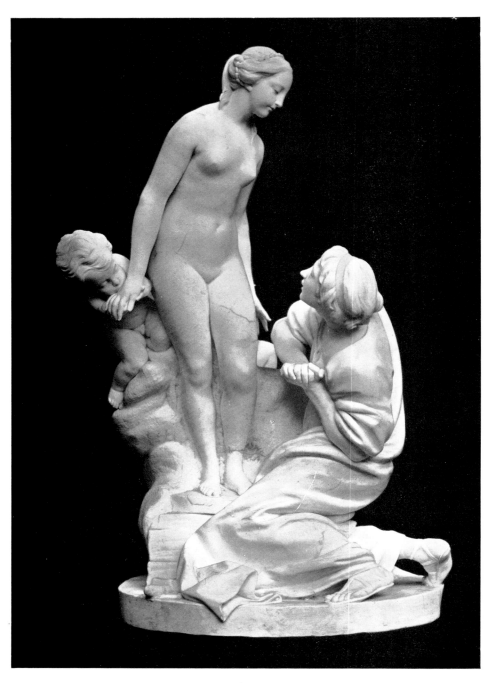

68. SÈVRES
ABOUT 1763

GROUP, BISCUIT PORCELAIN: 'PYGMALION AND GALATEA,'
FROM A MODEL MADE BY E.-M. FALCONET IN 1763
HEIGHT, $14\frac{1}{2}$ IN.
British Museum
See page 36

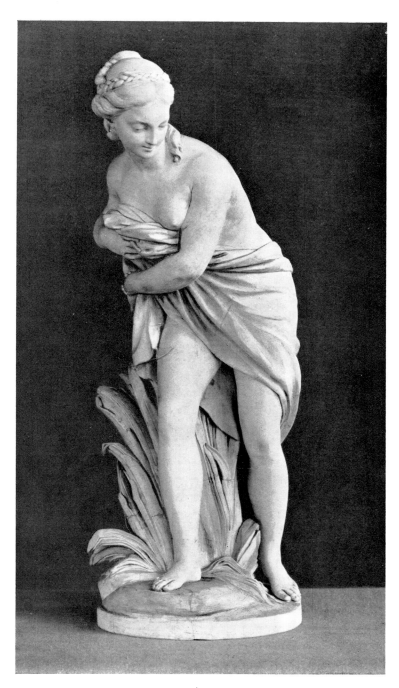

69. SÈVRES
ABOUT 1775

FIGURE OF A BATHER, BISCUIT PORCELAIN, FROM A MODEL MADE BY
LOUIS-SIMON BOIZOT IN 1774
HEIGHT, 2 FT. $2\frac{1}{4}$ IN.
Victoria and Albert Museum
See page 36

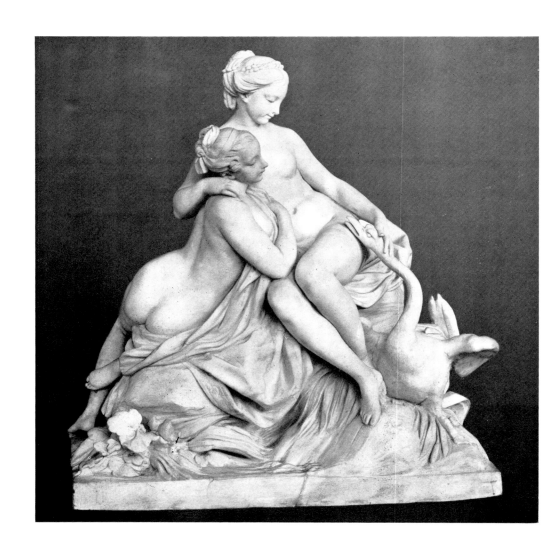

70. SÈVRES
ABOUT 1764

GROUP, BISCUIT PORCELAIN: 'LEDA AND THE SWAN,' FROM A
MODEL MADE BY E.-M. FALCONET AFTER BOUCHER IN 1764
HEIGHT, 13 IN.
Victoria and Albert Museum
See page 36

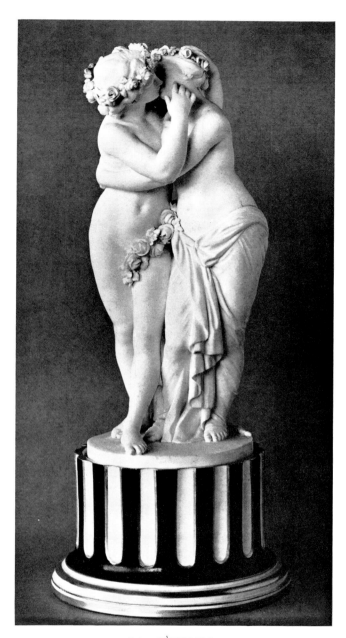

71. SÈVRES
ABOUT 1790

GROUP, BISCUIT PORCELAIN: 'CUPID AND PSYCHE,' FROM A
MODEL ADAPTED FROM THE ANTIQUE
HEIGHT, 12 IN.
Victoria and Albert Museum

See page 36

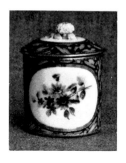

72. SÈVRES
DATED 1756, 1761

A. PLATE, PAINTED IN BLUE ENAMEL AND GILT. MARKS, IN
BLUE, CROSSED 'L'S', ENCLOSING 'D' (FOR THE YEAR 1756)
AND AN ANCHOR (FOR THE PAINTER CHARLES BUTEUX AÎNÉ)
DIAMETER, 9 IN.

B. POT AND COVER, PAINTED WITH FLOWERS IN COLOURS AND
GILT ON A 'ROSE POMPADOUR CAILLOUTÉ' GROUND. MARKS,
IN BLUE, CROSSED 'L'S' ENCLOSING 'I' (FOR THE YEAR 1761)
AND THE MARK OF THE PAINTER NOËL
HEIGHT, $2\frac{3}{4}$ IN.

Both Victoria and Albert Museum
See pages 38, 39

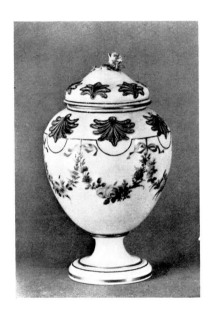

73. SÈVRES
ABOUT 1760–65

A. TRAY, PAINTED IN COLOURS AND GILT. ABOUT 1760
WIDTH, $5\frac{7}{8}$ IN.

B. VASE, PAINTED IN COLOURS AND GILT. MARKS, IN BLUE,
CROSSED 'L'S', ENCLOSING 'M' (FOR THE YEAR 1765) AND A
QUAVER (FOR THE PAINTER CORNAILLE)
HEIGHT, 8 IN.

Both Victoria and Albert Museum
See pages 38, 39

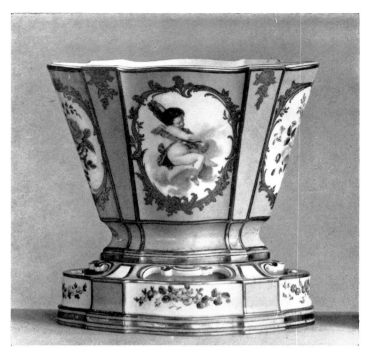

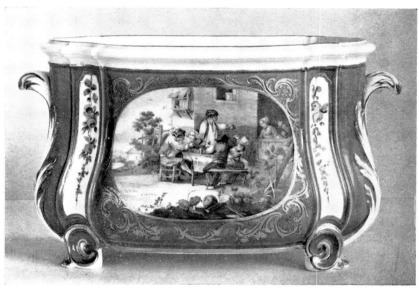

74. SÈVRES
ABOUT 1760

A. FLOWER-POT, PAINTED IN COLOURS AND GILT; 'ROSE POMPADOUR' GROUND. MARKS, IN BLUE, CROSSED 'L'S' ENCLOSING 'I' (FOR THE YEAR 1761) AND THE MARK OF THE PAINTER DUBOIS HEIGHT, $7\frac{1}{2}$ IN.

B. FLOWER-POT, PAINTED IN COLOURS AND GILT; TURQUOISE-BLUE GROUND. MARKS, IN BLUE, CROSSED 'L'S' ENCLOSING 'H' (FOR THE YEAR 1760) AND THE MARK OF THE PAINTER VIEILLIARD. LENGTH, 10 IN.

Both Victoria and Albert Museum. See pages 37, 38

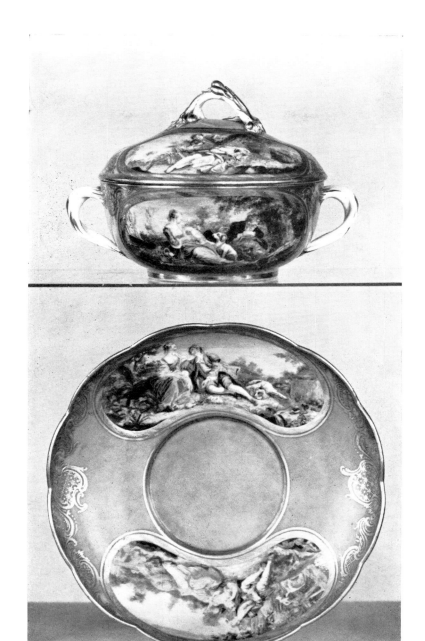

75. SÈVRES
DATED 1768

COVERED BOWL AND STAND, PAINTED IN COLOURS AND GILT;
TURQUOISE-BLUE GROUND. MARKS, IN BLUE, CROSSED 'L'S'
ENCLOSING 'P' (FOR THE YEAR 1768) AND THE MARK OF THE
PAINTER CHABRY FILS
DIAMETER OF STAND, $7\frac{7}{8}$ IN.
Victoria and Albert Museum. See page 37

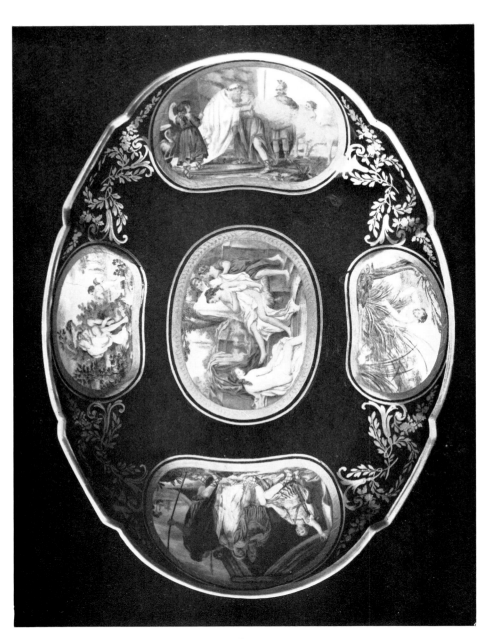

76. SÈVRES
DATED 1792

DISH, PAINTED IN COLOURS AND GILT; 'BLEU-DE-ROI' GROUND.
MARKS, IN BLUE, CROSSED 'L'S' ENCLOSING 'OO' (FOR THE
YEAR 1792) AND 'K' (THE MARK OF THE PAINTER DODIN)
LENGTH, $11\frac{1}{2}$ IN.
Sir Lionel Faudel-Phillips, Bart.
See page 37

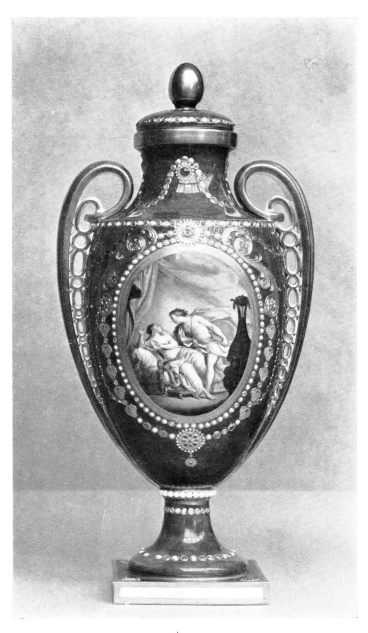

77. SÈVRES
DATED 1781

VASE, PAINTED IN COLOURS AND GILT, WITH JEWELLED
DECORATION; 'BLEU-DE-ROI' GROUND. MARK, IN BLUE, CROSSED
'L'S' ENCLOSING 'DD' (FOR THE YEAR 1781)
HEIGHT, $12\frac{1}{2}$ IN.
British Museum
See page 39

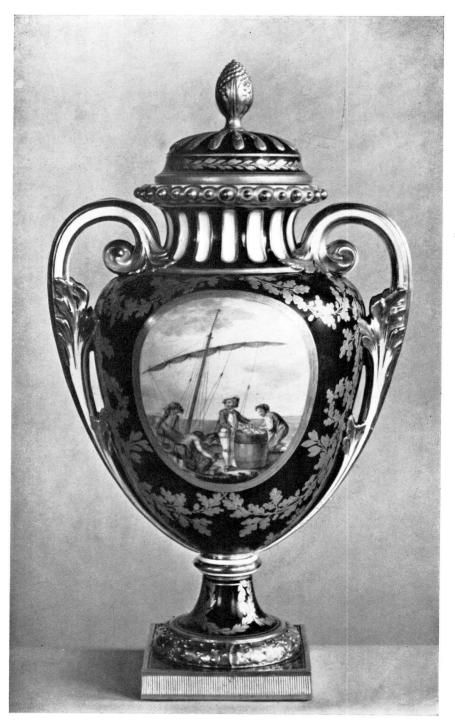

78. SÈVRES

MADE IN 1780

VASE MADE AS A PRESENT FROM GUSTAVUS III OF SWEDEN FOR
CATHERINE II OF RUSSIA, PAINTED IN COLOURS AND GILT;
'BLEU-DE-ROI' GROUND. MARKS, CROSSED 'L'S' AND 'LG'
(FOR THE GILDER LE GUAY OR LE GRAND)
HEIGHT, $19\frac{1}{2}$ IN.

Victoria and Albert Museum. See page 37

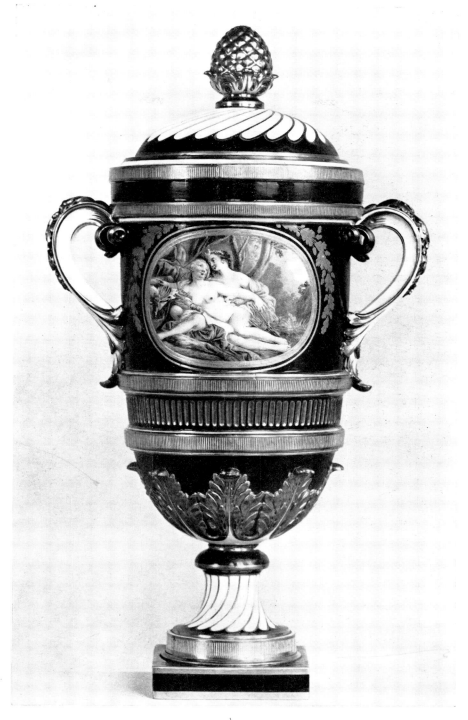

79. SÈVRES

MADE IN 1788

VASE MADE FOR TIPPOO SAHIB, PAINTED IN COLOURS AND GILT;
'BLEU-DE-ROI' GROUND
HEIGHT, $18\frac{1}{2}$ IN.
Victoria and Albert Museum. See page 37

80. SÈVRES

See page 38

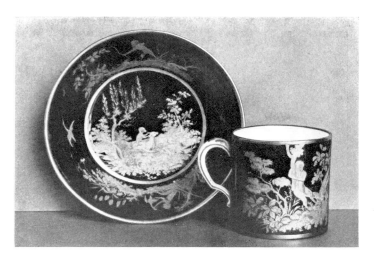

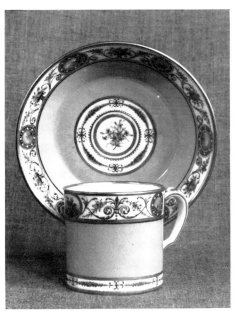

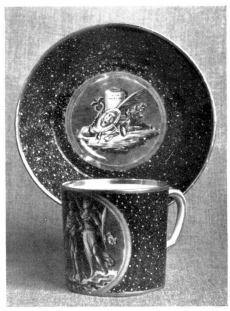

81. SÈVRES

LATE EIGHTEENTH CENTURY

A. CUP AND SAUCER, PAINTED IN GILT AND COLOURS ON AN AUBERGINE
GROUND IN THE MANNER OF LACQUER. MARKS, IN GOLD, CROSSED
'L'S' AND 'MM' (FOR THE YEAR 1790). ALSO 'L' AND A DOT (FOR
THE PAINTER LEVÉ PÈRE). HEIGHT OF CUP, 3 IN. *Jules Archdeacon*

B. CUP AND SAUCER, PAINTED IN COLOURS AND GILT; YELLOW
GROUND. MARKS, IN BLUE, CROSSED 'L'S' ENCLOSING 'JJ'
(FOR THE YEAR 1787) AND 'NQ' FOR THE PAINTER NICQUET
HEIGHT OF CUP, $2\frac{5}{8}$ IN. *Victoria and Albert Museum*

C. CUP AND SAUCER PAINTED IN CRIMSON MONOCHROME ON
BLUE IN A PANEL RESERVED ON A RED-PURPLE GROUND
SPECKLED IN IMITATION OF PORPHYRY. MARKS, 'RF' IN
MONOGRAM, 'SEVRES' AND 'GL' IN BLUE. HEIGHT OF CUP, $2\frac{7}{8}$ IN.
Victoria and Albert Museum
See pages 38, 39, 40

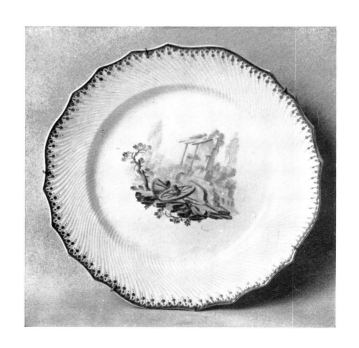

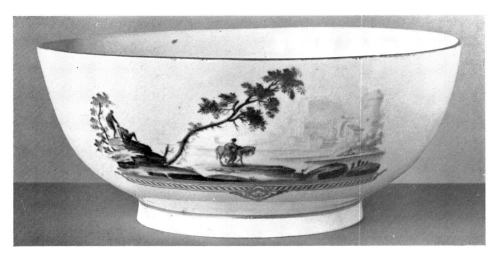

82. TOURNAY

ABOUT 1760

A. PLATE, PAINTED IN PURPLE MONOCHROME AND GILT
MARK, CROSSED SWORDS AND FOUR CROSSES, IN GILT
DIAMETER, $9\frac{1}{4}$ IN.
Sèvres, Musée Céramique

B. BOWL, PAINTED IN PURPLE MONOCHROME AND GILT
MARK, CROSSED SWORDS AND FOUR CROSSES, IN GILT
DIAMETER, 9 IN.
Victoria and Albert Museum

See pages 42, 43

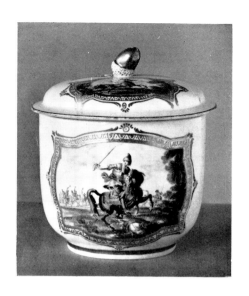

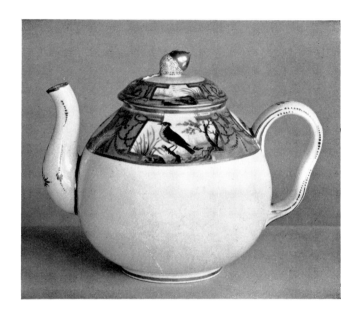

85. TOURNAY
ABOUT 1760–90

A. SUGAR-BASIN, PAINTED IN COLOURS AND GILT. MARK, A
TOWER, IN GILT
HEIGHT, $4\frac{3}{4}$ IN.

B. TEA-POT, PAINTED IN COLOURS AND GILT; 'BLEU-DE-ROI'
GROUND
HEIGHT, $5\frac{1}{8}$ IN.

Both Victoria and Albert Museum
See page 43

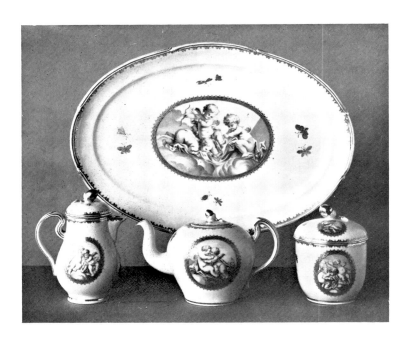

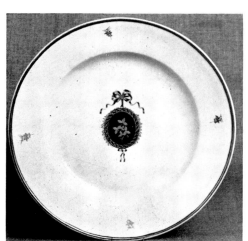
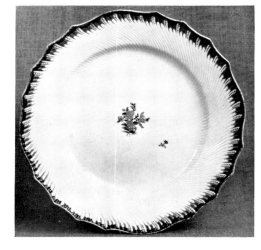

84. TOURNAY
ABOUT 1770–90

A. PART OF A SERVICE PAINTED IN PURPLE MONOCHROME
MARK, CROSSED SWORDS AND FOUR CROSSES, IN GILT
HEIGHT OF TEA-POT, $3\frac{5}{8}$ IN.
B. PLATE, PAINTED IN BLUE AND GILT
DIAMETER, $9\frac{1}{4}$ IN.
C. PLATE, PAINTED IN PURPLE AND GILT. MARK, CROSSED
SWORDS AND FOUR CROSSES, IN GILT. DIAMETER, $9\frac{3}{8}$ IN.
All Victoria and Albert Museum
See pages 42, 43

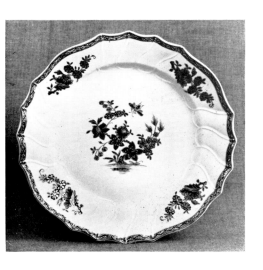
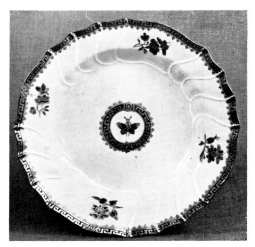
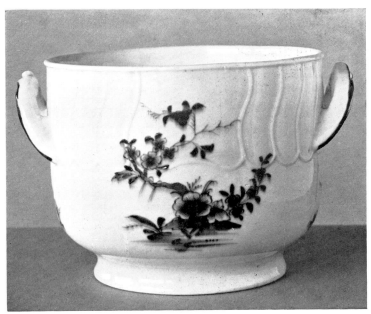

85. TOURNAY AND ARRAS
ABOUT 1775

A. PLATE, PAINTED IN UNDERGLAZE BLUE AND GILT. MARK,
CROSSED SWORDS AND FOUR CROSSES, IN GILT
DIAMETER, $9\frac{1}{8}$ IN.

B. PLATE, PAINTED IN BLUE AND GILT. MARK, A TOWER,
IN GILT. DIAMETER, $9\frac{3}{8}$ IN.

C. FLOWER-POT, PAINTED IN UNDERGLAZE BLUE. MARK,
'AR'. IN BLUE. ARRAS. HEIGHT, $4\frac{3}{4}$ IN.

All Victoria and Albert Museum

See pages 42–44

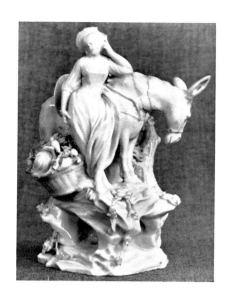

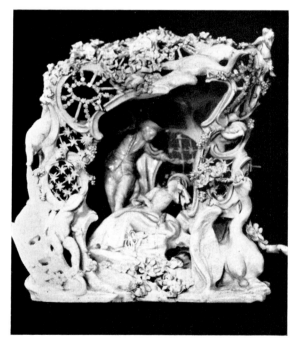

86. TOURNAY
ABOUT 1760

FROM MODELS BY NICOLAS LECREUX
A. GROUP, GLAZED WHITE PORCELAIN. HEIGHT, $5\frac{1}{4}$ IN.
Victoria and Albert Museum
B. GROUP, GLAZED WHITE PORCELAIN. HEIGHT, $9\frac{3}{4}$ IN.
Mme Louis Solvay
See page 44

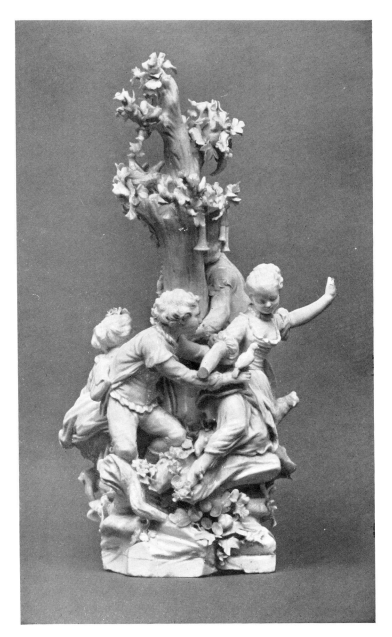

87. TOURNAY
ABOUT 1770

GROUP, GLAZED WHITE PORCELAIN, FROM A MODEL PERHAPS
BY NICOLAS LECREUX
HEIGHT, 12 IN.
Victoria and Albert Museum
See page 44

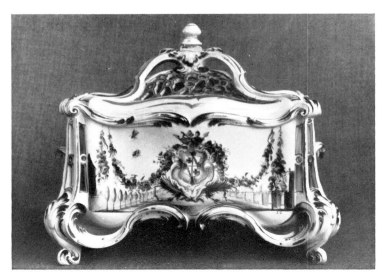

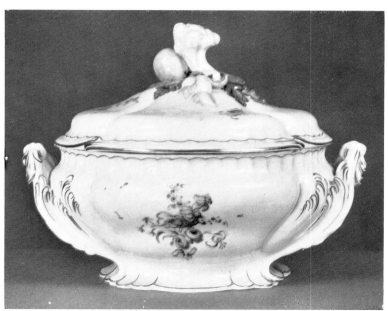

88. NIDERVILLER
ABOUT 1765 AND 1775

A. PASTILLE-BURNER (?) PAINTED IN COLOURS. MARK, 'BN' IN
MONOGRAM IN CRIMSON. HEIGHT, $6\frac{5}{8}$ IN.
Michael Moseley
B. SOUP-TUREEN, PAINTED IN CRIMSON AND GILT
MARK, CROSSED 'C'S' IN BLACK. HEIGHT, $8\frac{3}{4}$ IN.
Victoria and Albert Museum
See page 46

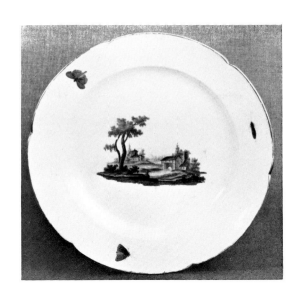

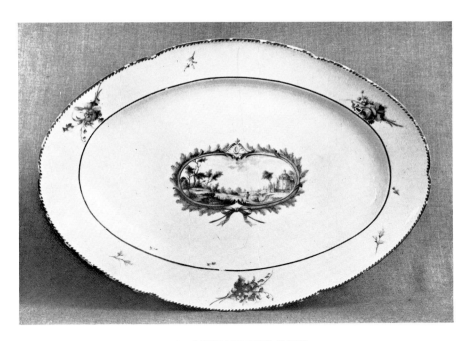

89. NIDERVILLER

ABOUT 1775–80

A. PLATE, PAINTED IN COLOURS. MARK, 'N' IN BROWN
DIAMETER, $9\frac{1}{2}$ IN.

B. DISH, PAINTED IN COLOURS. MARK, CROSSED
'C'S' IN BLUE ENAMEL. LENGTH, $16\frac{1}{4}$ IN.

Both Victoria and Albert Museum

See page 46

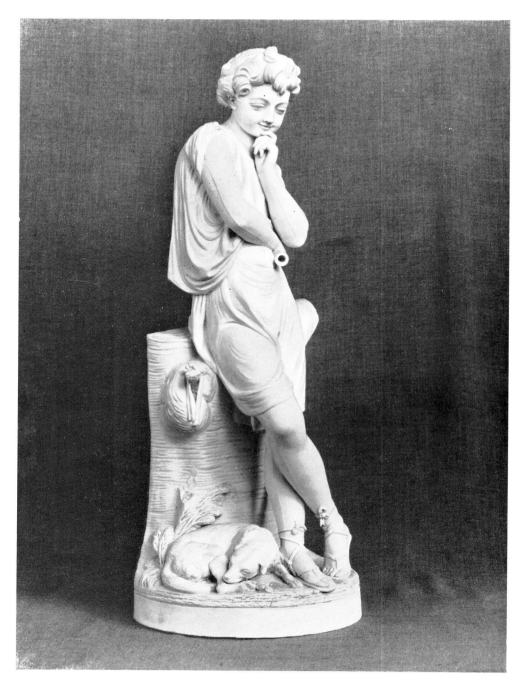

90. NIDERVILLER
ABOUT 1775
FIGURE OF A SHEPHERD-BOY, BISCUIT PORCELAIN, FROM A
MODEL PERHAPS BY LEMIRE
HEIGHT, 24 IN.
Victoria and Albert Museum
See page 47

91. NIDERVILLER and LUNÉVILLE

ABOUT 1765–75

BISCUIT PORCELAIN

A. FIGURE OF A MAN SYMBOLISING AUTUMN, FROM A MODEL
PROBABLY BY LEMIRE. MARK, 'NIDERVILLE', IMPRESSED
HEIGHT, 7½ IN.

B. FIGURE OF A BEGGAR, FROM A MODEL PERHAPS BY PAUL-
LOUIS CYFFLÉ. MARK, 'NIDERVILLE', IMPRESSED. HEIGHT, 6 IN.

C. GROUP, THE DEAD BIRD, FROM A MODEL BY PAUL-LOUIS CYFFLÉ.
MARK, 'TERRE DE LORRAINE', IMPRESSED. HEIGHT, 8½ IN.

All Victoria and Albert Museum. See pages 46, 47

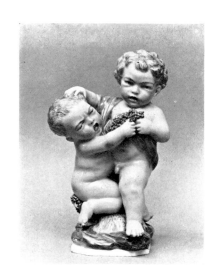

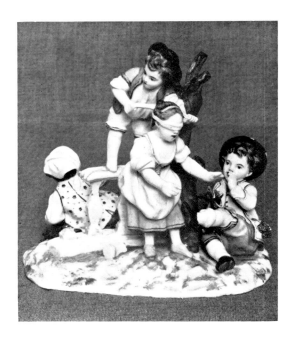

92. STRASBURG
ABOUT 1775

A. GROUP, PAINTED IN COLOURS. MARK, 'IH' IN MONOGRAM,
IMPRESSED. HEIGHT, $6\frac{7}{8}$ IN.
Victoria and Albert Museum
B. GROUP, PAINTED IN COLOURS. MARK, 'IH' IN MONOGRAM,
IMPRESSED. HEIGHT, $7\frac{1}{2}$ IN.
Bedford, Cecil Higgins Museum
See page 45

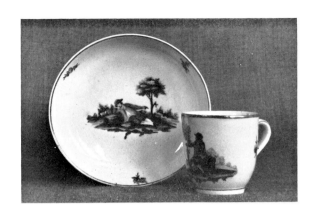

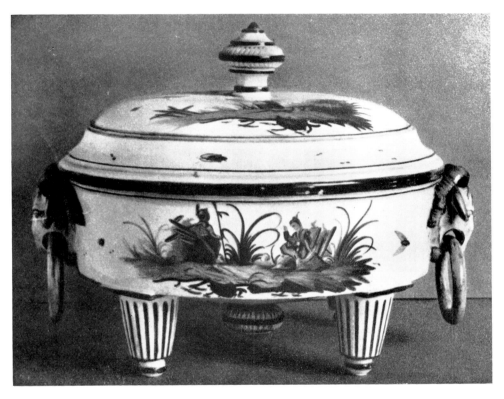

95. STRASBURG
ABOUT 1775
A. CUP AND SAUCER, PAINTED IN COLOURS. MARK, 'IH' IN
MONOGRAM IN BLUE. HEIGHT OF CUP, $2\frac{7}{8}$ IN.
Victoria and Albert Museum
B. SOUP-TUREEN, PAINTED IN COLOURS. MARK, 'IH' IN
MONOGRAM IN BLUE. HEIGHT, $8\frac{1}{4}$ IN.
Sèvres, Musée Céramique
See page 45

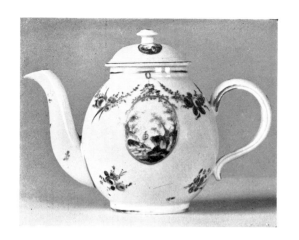
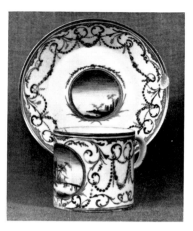
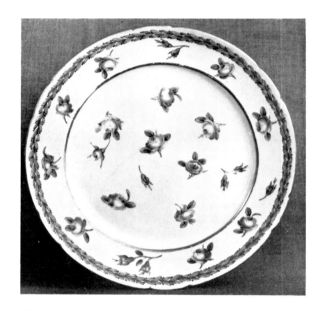

94. ETIOLLES, BORDEAUX, PARIS
ABOUT 1770–90

A. TEA-POT, PAINTED IN COLOURS. MARK, 'ETIOLLE XBRE
1770 PELLEVÉ'. ETIOLLES; DATED 1770. HEIGHT, $5\frac{1}{4}$ IN.

B. CUP AND SAUCER, PAINTED IN COLOURS. MARK, 'VV' IN
MONOGRAM IN GOLD. BORDEAUX; ABOUT 1781–1787
HEIGHT OF CUP, $2\frac{3}{8}$ IN.

C. PLATE, PAINTED IN COLOURS. MARK, 'CP' UNDER A CORONET
(FOR CHARLES-PHILIPPE, COMTE D'ARTOIS), STENCILLED IN
RED. PARIS, FAUBOURG SAINT-DENIS; ABOUT 1780–90
DIAMETER, $9\frac{1}{2}$ IN.

All Victoria and Albert Museum
See pages 48, 60, 62, 64

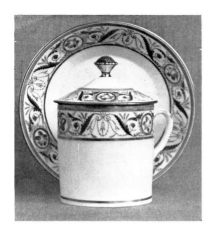
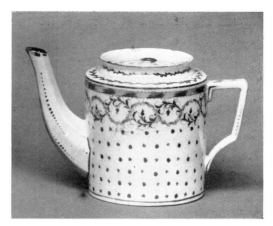

95. PARIS
ABOUT 1775–93

A. CUP AND SAUCER, PAINTED IN COLOURS. MARK, 'MANUFRE
DE MGR LE DUC D'ANGOULÊME À PARIS', STENCILLED IN RED
PARIS, RUE DE BONDY; ABOUT 1790. HEIGHT OF CUP, $4\frac{7}{8}$ IN.
B. TEA-POT, PAINTED IN COLOURS. MARK, 'B POTTER 4' IN
BLUE. PARIS, RUE DE CRUSSOL; ABOUT 1790. HEIGHT, $3\frac{3}{4}$ IN.
C. PLATE, PAINTED IN COLOURS. MARK, A CROWNED 'A'
STENCILLED IN RED. PARIS, RUE THIROUX; ABOUT 1775–93
DIAMETER, $9\frac{1}{2}$ IN.
All Victoria and Albert Museum
See pages 48, 68

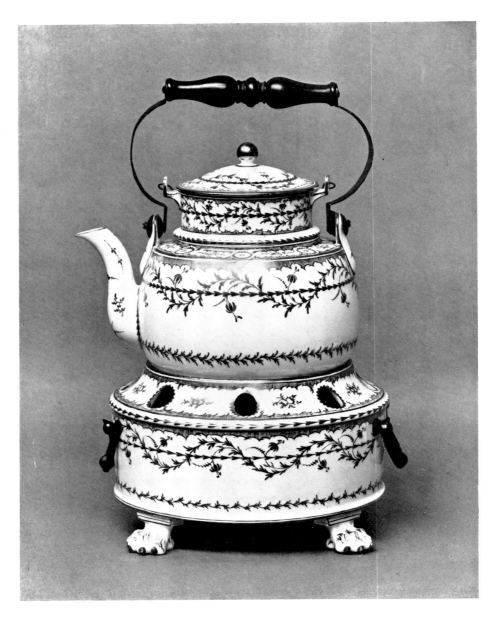

96. PARIS, CLIGNANCOURT
ABOUT 1775–91
KETTLE, PAINTED IN GILT. MARK, 'LSX' IN MONOGRAM,
STENCILLED IN RED
HEIGHT OVERALL, 12 IN.
Victoria and Albert Museum
See page 48